A TREASURY OF
BOOKPLATES

FROM THE

RENAISSANCE TO THE PRESENT

SELECTED AND WITH AN INTRODUCTION BY
FRIDOLF JOHNSON

DOVER PUBLICATIONS, INC., NEW YORK

Published in Canada by General Publishing Company, Ltd., 30 Lesmill Road, Don Mills, Toronto, Ontario.
Published in the United Kingdom by Constable and Company, Ltd., 10 Orange Street, London WC2H 7EG.

A Treasury of Bookplates from the Renaissance to the Present is a new work, first published by Dover Publications, Inc., in 1977.

International Standard Book Number: 0-486-23485-1
Library of Congress Catalog Card Number: 76-57521

Manufactured in the United States of America
Dover Publications, Inc.
180 Varick Street
New York, N.Y. 10014

INTRODUCTION

The child who scrawls his name on the flyleaf of his book is no different, except in personal resources, from the bibliophile who uses a specially designed and printed bookplate: both thereby signify ownership of a prized possession. Such marks of ownership are basically safeguards against loss or theft. Inscriptions are found in great variety. A schoolboy might write, "I pity the lake, I pity the brook; I pity the one that takes this book!" Sir Walter Scott's note to book borrowers reads, "Please return this book; I find that though many of my friends are poor mathematicians, they are nearly all good bookkeepers." Many book owners have called upon Holy Writ for authority: "Go ye rather to them that sell, and buy for yourselves," or, "The ungodly borroweth and payeth not again!" Such simple statements as "From the Library of . . ." are much more common and less pointed; the equivalent Latin words *ex libris* have been used extensively and have come to be universally understood as an alternate name for a bookplate.

A handwritten name is certainly sufficient for the purpose of identification, but an attractive bookplate is more impressive and convenient. Ever since there were books to own, bookplates to paste into them have been made, and in variety and quantities great enough to form an important but often neglected department of the graphic arts. The roster of fine artists and discriminating patrons who have given serious attention to the design of bookplates is studded with distinguished names of all periods since the fifteenth century. And the study and collection of the finest examples are not considered beneath the dignity of scholars in many great libraries and museums.

A bookplate may be strictly utilitarian and unadorned, bearing merely the owner's name, or it may be a work of art created by a capable designer and produced by various methods, including woodcut, wood engraving, linoleum cut, steel or copper engraving, etching, aquatint, lithography, decorative typography, or any of the modern methods of photographic reproduction.

The idea of a bookplate is believed to have originated in Germany, and the earliest known is tentatively dated 1450 (Figure A). It belonged to Johannes Knabensberg, called Igler (from the German word for hedgehog), chaplain to the family of Schönstett. It is a crude woodcut, about 5½ by 7½ inches, of a hedgehog with a ribboned German inscription above it which reads, "Hans Igler that the hedgehog may kiss you." Copies are extremely rare, and those that have been discovered so far have all been roughly colored by hand.

The date of the Igler bookplate is open to question, however, principally because the year 1450 approximately marks the birth of printing from movable type, and thus Igler would have had only handwritten manuscripts and perhaps a few block books into which to paste his bookplate. Manuscript books were precious and uncommon enough to discourage casual handling or lending, and their uniqueness would have provided their own identification. Just the same, the inscription on Igler's bookplate must be the first to warn against stealing or injuring a book.

We may be on firmer ground in claiming priority for another bookplate (Figure B), also German, which is a woodcut about 2½ inches square and represents an angel holding a shield on which is displayed an ox with a ring passed through his nose—the arms of the Brandenburg family. It is rudely hand colored and the examples extant, more numerous than the Igler, were printed on odd scraps of paper obviously salvaged from printer's waste, clearly indicating the scarcity of this material at that time. There is no lettering on

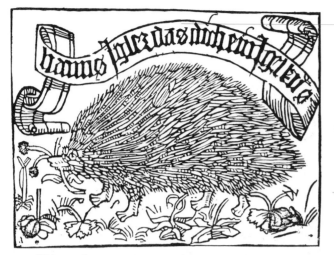

Figure A

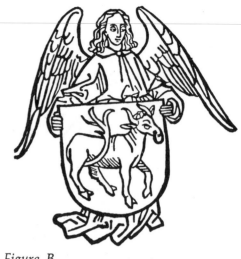

Figure B

it to show that it was really intended to be a bookplate, but it has been identified as one by a Latin inscription (in manuscript) recording that Brother Hilprand of Biberach had presented the books in which the plate is found to the Carthusian Monastery of Buxheim. It has been variously dated at 1470–1480.

Which of these two bookplates came first may never be satisfactorily demonstrated. At any rate, after Gutenberg the spread of printing in Europe was so rapid that by 1480 it had begun to expand into independent publishing. The booming book trade made the formation of both large and small libraries economically feasible, and, especially in Germany, commissions for executing bookplates were entrusted to foremost artists. Albrecht Dürer is supposed to have designed at least twenty bookplates, their heraldic compositions creating a model for some much later bookplates of his country that came to be known as the Old German style. Dürer is also credited by some authorities with the first dated bookplate; it bears the Latin inscription "Liber Hieronimi Ebner" and the year, 1516.

Fine bookplates were also designed by such artists as Lucas Cranach the Elder, Bartel and Hans Sebald Beham, Virgil Solis, Hans Burgkmair, Hans Holbein the Younger, Jost Amman, and others. In France and Italy of that time bookplates were not common, the custom there being to signify ownership by having family coats of arms stamped into decorative bindings, either on the front cover or on the spine.

Early German bookplates are principally armorial in subject, but their actual design was no doubt strongly influenced by the distinctive woodcut devices or marks used by printers to identify their presses. These marks are usually quite decorative treatments of allegorical figures, monograms, symbols, animals and mythical creatures, and the like. The use of armorial bookplates was a natural consequence of a way of life in which heraldry played such an important function. Designs of more general interest began to appear with the emergence of the affluent and educated middle classes, though to this day heraldic designs are preferred by some—with or without justification.

The black-line woodcut, under the hands of Dürer and his successors, reached a high level of perfection, exhibiting a much greater refinement in fine lines and shading. However, by the end of the sixteenth century it was largely superseded by copperplate engraving, which permitted greater freedom for the execution of intricate and fully shaded embellishments and the use of elaborate flourishes made fashionable by the great writing masters. Copperplate engraving, despite the additional expense and trouble of printing the plates separately from the letterpress text, became extremely popular for the illustration of books. All over Europe the collecting of books and art began on an unprecedented scale under the influence of great heads of state—Charles I in England, Cardinals Richelieu and Mazarin in France, Queen Christina in Sweden, the Holy Roman Emperor Rudolph II, Philip IV in Spain, and Pope Urban VIII in Italy. Books of amazing magnificence and dimensions were ordered, and they were filled with equally magnificent engravings, their ownership often certified by correspondingly large book-

plates. One of the largest bookplates was made in the late seventeenth century for a Count Maximilian Louis Briener, an official of the emperor of Austria in Lombardy. It measures no less than 14 inches high, a size hardly suitable for books now in general circulation.

The eighteenth century was the golden age of engraving, supporting a fantastic number of artists, many of whom are familiar to us today. With so many splendid commissions to attend to, bookplates must have been considered routine jobs by their engravers, who did not bother to sign them, making their attribution difficult. William Hogarth is known to have engraved several, but he left them unsigned. (In England, as on the Continent, subjects were predominantly armorial, often without name or date, presenting interesting problems in heraldry and decorative style for collectors with a taste for research.) Engravers strove for fine workmanship and elegance, filling the plate with elaborate decorations and vignettes, and rendering inscriptions in what we now call copperplate script and engraver's roman; thus their designers followed closely the prevailing mode in decorative art. The finest early American bookplates may be traced to English engravers of this period; Colonial engravings are not nearly as well executed but are highly prized by collectors nevertheless. It was not long before America produced a number of engravers who could be compared favorably with Continental craftsmen.

After 1800, the more expensive copperplates gave way gradually to engravings on the end grain of wood blocks which, like the cruder woodcuts, could be printed simultaneously with type on greatly improved presses. The white-line technique was perfected, in England, by Thomas Bewick (1753–1829), and his followers became remarkably skillful in creating subtle tones by means of cutting parallel, closely spaced white lines with a graver. In America the technique was successfully imitated by Alexander Anderson (1775–1870), the first American to engrave in wood. During his long life he was the inspiration for a new generation of engravers.

Though there was a steady demand for popular prints and inserts for books and magazines made by other processes—copper and steel engraving, aquatint, mezzotint, and lithography—wood engraving became the principal medium for general purposes. The tradition of engraving bookplates on metal was continued until sometime after 1900 by such masters as Charles William Sherborn and

George W. Eve in England and Edwin Davis French, Sidney L. Smith, and J. Winfred Spenceley in the United States, but all succumbed to the Victorian taste for vignettes and fussy over-ornamentation suggestive of bank note engraving.

Probably the most far-reaching, but not necessarily the most beneficial development in bookplate production was the invention of photoengraving. This process, by which an artist's drawing can be photographically reduced or enlarged and transferred mechanically onto a metal plate for printing, had by 1900 almost completely supplanted hand engraving. Photoengraving thus greatly expanded the scope of graphic art, and, incidentally, the possibilities for bookplate designs by non-professionals. The much lower cost of photoengraving put the bookplate within reach of a much greater number of people at the same time that the general increase in literacy encouraged the formation of personal and institutional libraries. Without recourse to hand engraving, any kind of pen drawing and lettering, good or indifferent, could easily be printed in exact facsimile, opening the way for artists ranging from rank amateurs to the finest draughtsmen. Similarly, the range of subjects grew ever wider according to the personal inclinations and particular abilities of the artists employed in making the drawings. Pictorial bookplates became extremely popular and favorite illustrators and poster artists were frequently called upon to design bookplates.

The Victorians, with their predilection for "pretty things," were very industrious in assembling scrapbooks of souvenirs, trade cards, and other memorabilia, and have thus preserved for us many fine old bookplates which might otherwise have been lost or destroyed in the burning or rebinding of dilapidated books. The collecting of bookplates was probably first taken up during the last half of the nineteenth century. In 1875, *Ex-Libris Francais*, by A. Poulet-Malassis, appeared, and in 1880 was published *A Guide to the Study of Bookplates*, by J. Leicester Warren (Lord Tabley). Warren was the first to attempt a systematic classification of bookplates by styles, from which their age could be deduced. These two books set off a wave of bookplate activity and were followed in quick succession by many copiously illustrated books on English, French, and German bookplates, still valuable sources for reference and identification. One of the most comprehensive of these was Henry W. Fincham's

Artists and Engravers of British and American Book Plates (1897). It lists more than 1,500 artists and engravers as well as the bookplates they executed, with a separate index of those for whom the bookplates were made. Charles Dexter Allen's well-documented study *American Book Plates*, first published in 1894 and reprinted many times, remains the standard guide to early American and nineteenth-century American bookplates.

On February 10, 1891, a few ardent bookplate collectors met in London to establish the Ex Libris Society, and by the end of the year there were about 300 members in England, the Continent, and the United States. Very soon after its founding the Society began publishing its *Journal of the Ex Libris Society*, which continued until 1909, when eighteen volumes in all had been issued. From that time on, local and national bookplate societies have flourished at one time or other in many parts of the world.

Doubtless the growing vogue for collecting bookplates was a potent factor in stimulating the demand for new ones, not only for personal use but for exchange with other collectors. Interest in bookplates reached a peak around the turn of the century, then began to decline during World War I, when communication between collectors and artists was more difficult. It revived in the '20s and '30s, and a new crop of bookplate societies sprang up; collecting languished during the second World War, only to come to life again in the '50s. Since that time, bookplate activity has spread to many new localities; in Europe alone there are at present bookplate societies in Austria, Belgium, England, Czechoslovakia, Denmark, Finland, France, Germany, The Netherlands, Italy, Portugal, Spain, Sweden, and Switzerland.

The first bookplate society in the United States was founded in Washington, D.C., and lasted long enough to publish four numbers of its journal, *Ex Libris*, from July 1896 to April 1897. The California Bookplate Society, under Sheldon Cheney, published *California Book-Plates* from 1906 to 1911. Harry Alfred Fowler, of Kansas City, was a longtime leader in bookplate circles until his death in 1959. His first publication was *The Ex Libran*, a handsome and now rare booklet issued quarterly during 1915. Fowler was a founding member and mainstay of the American Bookplate Society, which issued its first yearbook in 1915. Under his editorship and financial support the Society published a number of periodicals between 1913 and 1925 with various titles, of which the hardbound *Bookplate Annual* (1921–1925) is the best known. The 1923 and 1924 editions contain directories of American and European bookplate artists and their fees. Prices vary greatly, from twenty-five to several hundred dollars. Franz von Bayros at that time was willing to make a bookplate to order for the modest sum of $150, but there were a few who charged as little as fifteen dollars.

More or less a continuation of the American Bookplate Society is the American Society of Bookplate Collectors and Designers, which celebrated its fiftieth anniversary in 1972. After a few years of relative inactivity, in 1970 the Society came under the energetic leadership of Mrs. Audrey Arellanes of Pasadena, who attracted many new members, including libraries and museums. In 1973 the Society published an impressive membership directory containing 118 bookplates owned or designed by members; some were reproductions, but most were actual bookplates mounted on the pages. The Society's quarterly, *Bookplates in the News*, keeps members informed of bookplate affairs all over the world.

Through bookplate societies and their publications, collectors and designers from almost every country are brought together. Entire collections are bought and sold; many of these are eventually acquired by libraries and institutions. Most collections are built up through correspondence and the exchange of duplicates. Many collectors commission as many personal designs from different artists as they can afford, thus augmenting their resources for exchange. It is not unusual for a single collector to have from a dozen to as many as a hundred different bookplates of his own for exchange. Bookplate correspondence is time-consuming, and for simple exchanges it is considered perfectly proper to use a brief standardized message specially printed for the purpose; collectors exchanging internationally surmount the language barrier by having these exchange forms printed in several translations.

The literature on bookplates is immense. Winward Prescott's by no means complete *A Bibliography of Bookplate Literature* (1926) lists approximately one thousand titles of books and journals. Audrey Arellanes' *Bookplates: A Selected Annotated Bibliography of Periodical Literature* (1971) contains no less than 5,445 entries. Besides all these items there must be thousands of unrecorded pamphlets, booklets, and portfolios issued strictly for private circulation.

As previously noted, the design of *ex libris* offers unlimited scope with respect to subject, style, and medium. In every country the earliest designs are mostly armorial or allegorical. Their dates and country of origin can usually be determined by style and inscriptions. English armorials —with which most collectors are familiar—are roughly classified as Carolean (ca. 1690), of which there are not many; Restoration (ca. 1700), also uncommon; Jacobean (1700–1750); Baroque (1740–1760); and Chippendale (1750–1780). After Chippendale came a much plainer style incorporating spade shapes, shields, and simple wreaths or festoons, closely followed by the Romantic style, in which, as in many Bewick wood engravings, an armorial shield is displayed against a background of trees and foliage.

Library interiors, book piles, and even portraits, besides allegorical subjects, are fairly common in early non-armorial bookplates. A much wider choice of subjects began to appear about the middle of the past century, and this trend was greatly accelerated when photoengraving began to replace hand engraving. The somewhat stilted designs of traditional engravers gave way to less conventional pictorial subjects freely drawn by artists normally associated with the illustration of books and magazines. Some of the most charming of all bookplates are those produced in England by such artists as Walter Crane, Kate Greenaway, Hugh Thomson, and Robert Anning Bell.

Ex libris were always popular in Germany and Austria, and a profusion of bookplate books and lavish portfolios have come from there. German artists were prompt to employ the newly invented lithographic process for producing bookplates in several colors, a trend not followed to any great extent elsewhere. During the *Jugendstil* period Germany and Austria were also the principal sources for bookplates made by etching, aquatint, and gravure. Many were made by academic artists and are more like art prints than bookplates, with nude figures predominating and with inscriptions constituting a negligible part of the design.

For some reason the bookplate has never been very important in American graphic art compared to Europe, though, in addition to the interest in California, Boston enjoyed a brief renaissance around 1910, and the Troutsdale Press published a number of fine monographs on leading bookplate engravers. During the 1930s the bookplate received considerable attention through the work of Rockwell Kent, whose style and conceptions were peculiarly appropriate.

Interest in bookplates now appears to be on the rise again. The concept of an *ex libris* as a fine engraving on a small scale appears to be gaining currency, and, as in all art, national distinctions are diminishing. Very fine work is now being done in European countries previously uninterested in the art—it is often difficult to guess from a modern bookplate's style if it came from Russia, Poland, Estonia, or some Western European area.

Bookplates are generally more modest and less ostentatious than before, and also more uninhibited. The private nature of a bookplate's distribution has encouraged erotic themes, and a book recently published in Hamburg contains almost one hundred erotic bookplates; the majority of these are from the hands of fine artists. The small book label is gaining in popularity, and many of these are done calligraphically or in decorative typography, with type and ornaments used with admirable restraint.

These new trends show that the study and collecting of bookplates is still an amiable and popular pursuit which can bring pleasures and enlightenment of many kinds. The bookplate, though a minor, often little considered graphic art form, has nevertheless had considerable appeal for art lovers and collectors since the time of Dürer; as long as books are printed there will be bookplates made to adorn them.

This collection of bookplates, arranged chronologically by country, comes from a wide range of sources but does not attempt to be a definitive or scholarly treatment. Thus information concerning the medium, the original size, or the exact date of each bookplate has for the most part not been included. The captions indicate the artist and the original owner (in cases where this is not obvious from the illustration), but the date is given only when it is of particular historical interest. The reader is referred to the Index of Artists for more specific indications of the dates of their lives.

Woodstock, N.Y. Fridolf Johnson

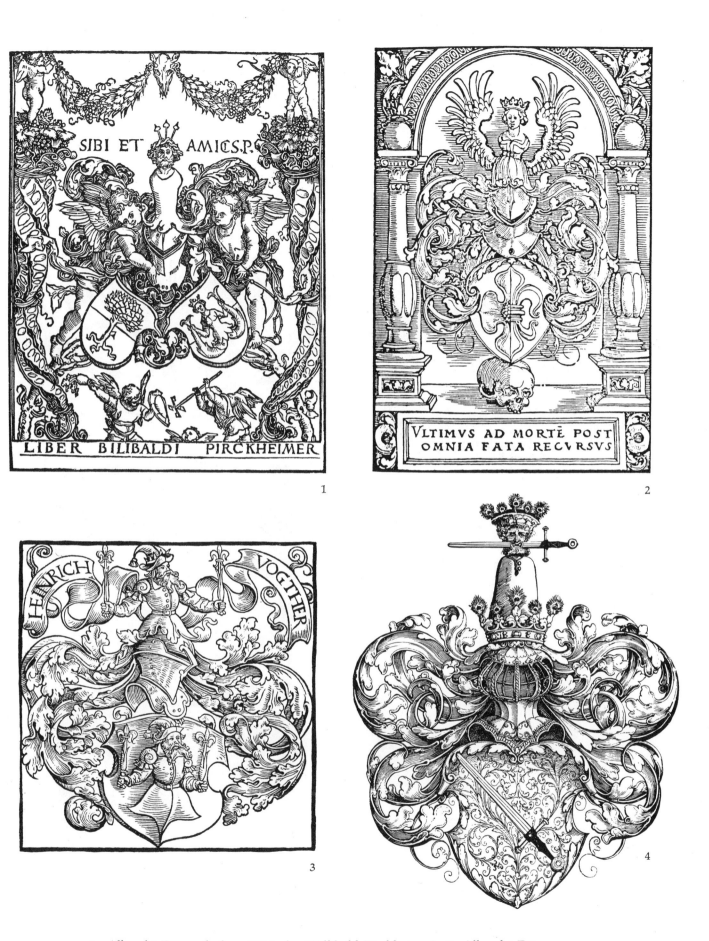

1: Albrecht Dürer (before 1503, for Willibald Pirckheimer). 2: Albrecht Dürer (ca. 1515, for Lazarus Spengler). 3: Heinrich Vogtherr (ca. 1537). 4: Anonymous (after 1530, for Christof Kress von Kressenstein).

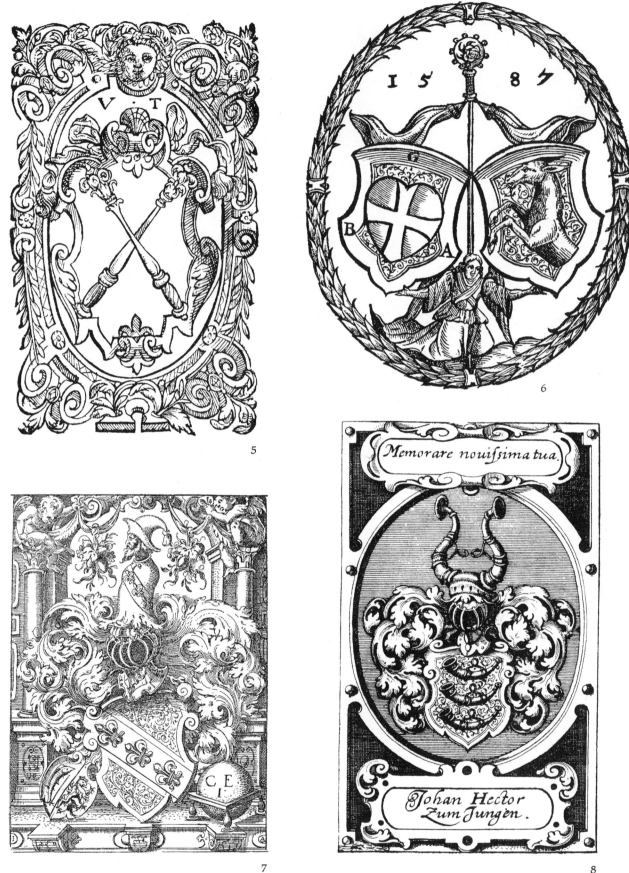

5: Anonymous (ca. 1560, for the University of Tübingen). 6: Anonymous (1587, for Benedikt Gangenrieder, Abbot of Thierhaupten). 7: Jost Amman (ca. 1583, for Christian A. Gugel von Brand). 8: Anonymous (ca. 1590).

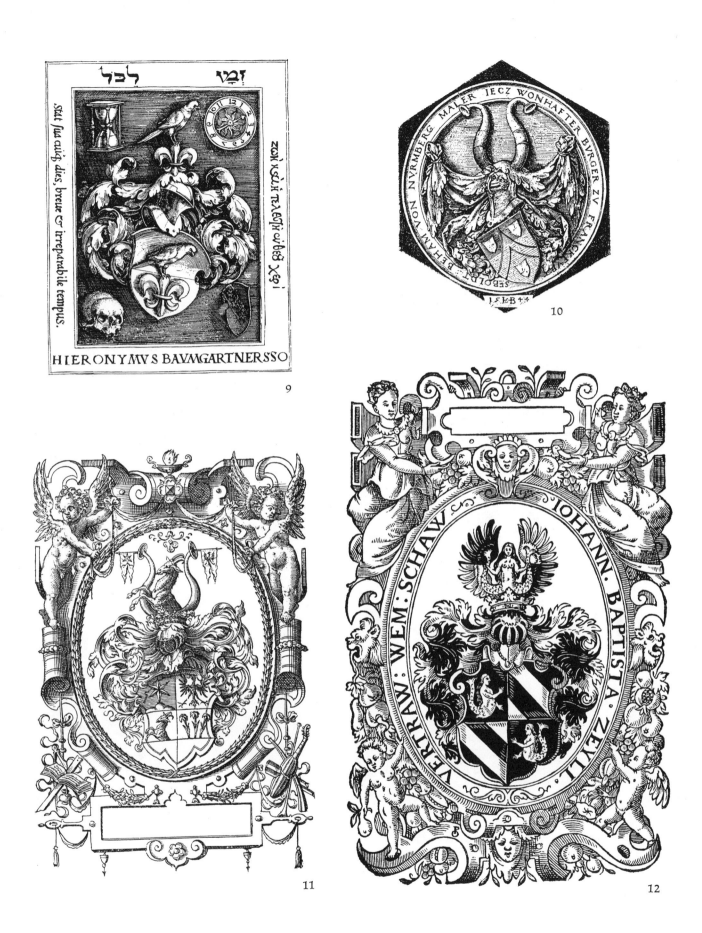

9: Barthel Beham (ca. 1530). 10: Hans Sebald Beham (1544, for himself). 11: Jost Amman (ca. 1590, for Johann Jakob Märtz). 12: P. Opel (1593, for Johann Baptist Zeyll).

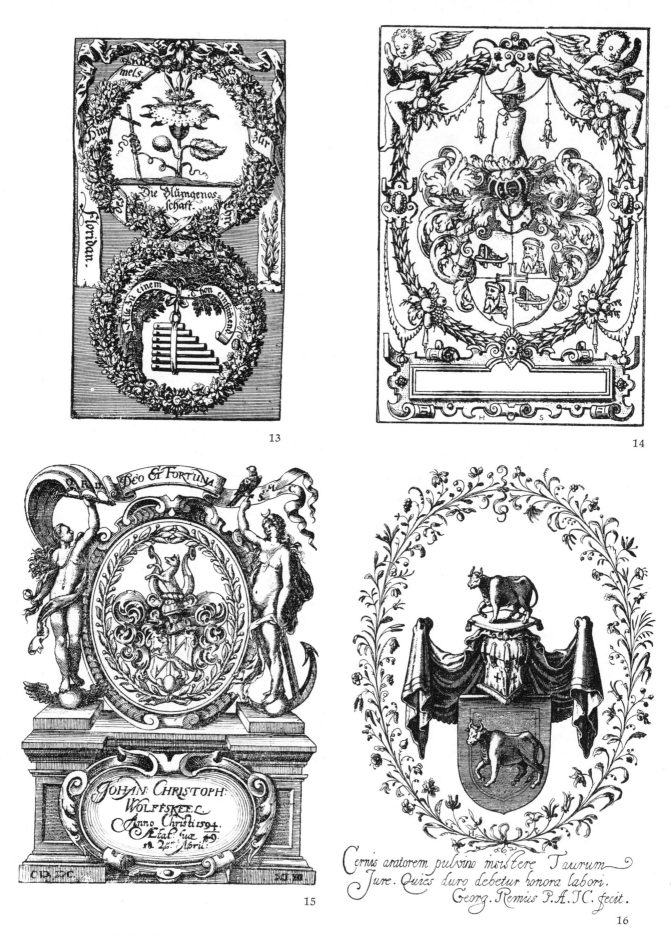

13

14

15

16

13: Joachim von Sandrart (for Sigmund von Birken). 14: Hans Sibmacher (for Veit August Holzschuher). 15: Anonymous. 16: Heinrich Ulrich (for Georg Rehm).

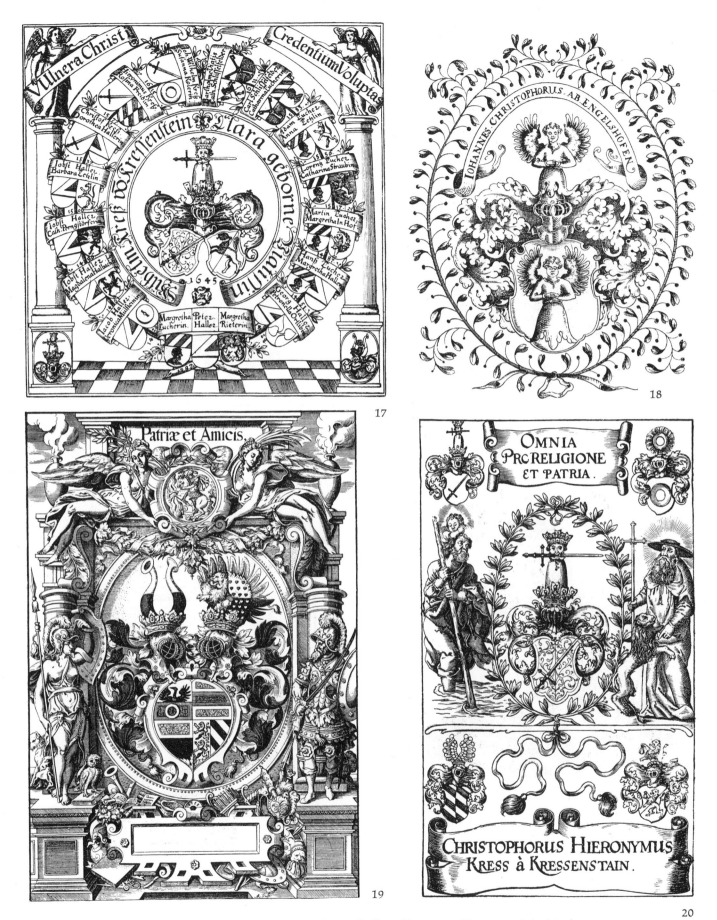

17: Raphael Custos (for Wilhelm and Clara Kress von Kressenstein). 18: Anonymous (for Johann Christof von Engelshofen). 19: Andreas Khol (for the Pfinzing-Grundlach family). 20: Anonymous (for Christof Hieronymus Kress von Kressenstein).

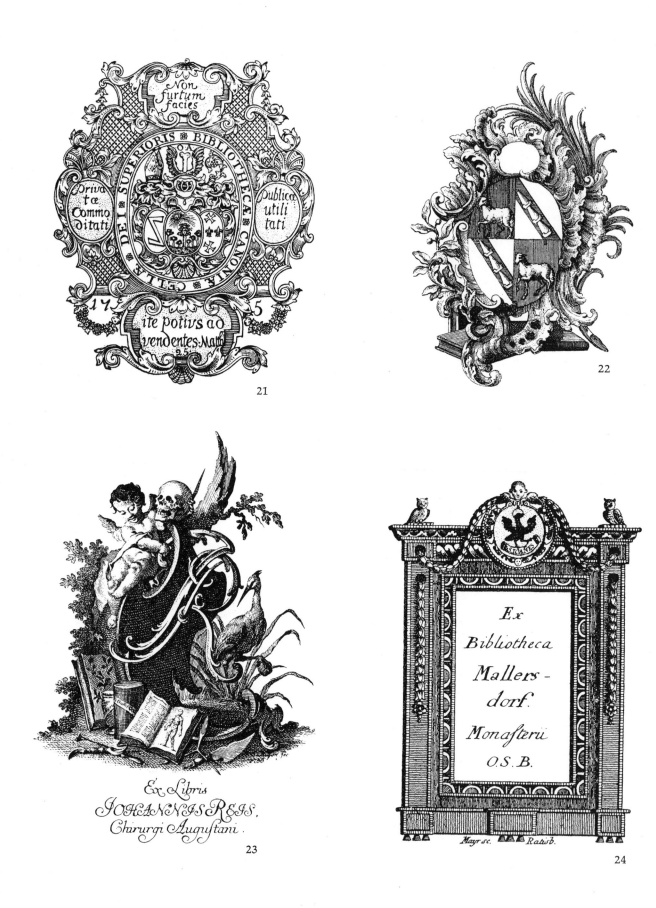

21: Anonymous (for the monastery of Oberzell-am-Main). 22: Anonymous (for Georg Wilhelm Friedrich Löffelholz von Kolberg). 23: Johann Esaias Nilson (for Johann Reis). 24: Mayr (for the monastery of Mallersdorf).

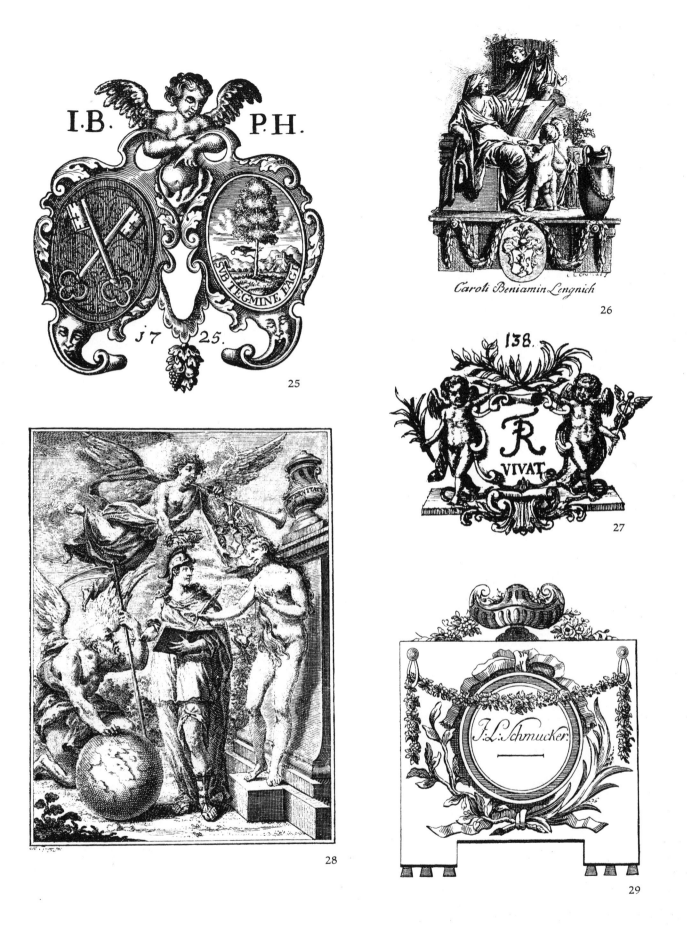

25: Anonymous (for the monastery of Högelwörth). 26: Carl Leberecht Crusius (for Karl Benjamin Lengnich). 27: Anonymous (for Luise Dorothea, Duchess of Sachsen-Gotha). 28: Martin Tyroff (for Johann David Köhler). 29: Anonymous.

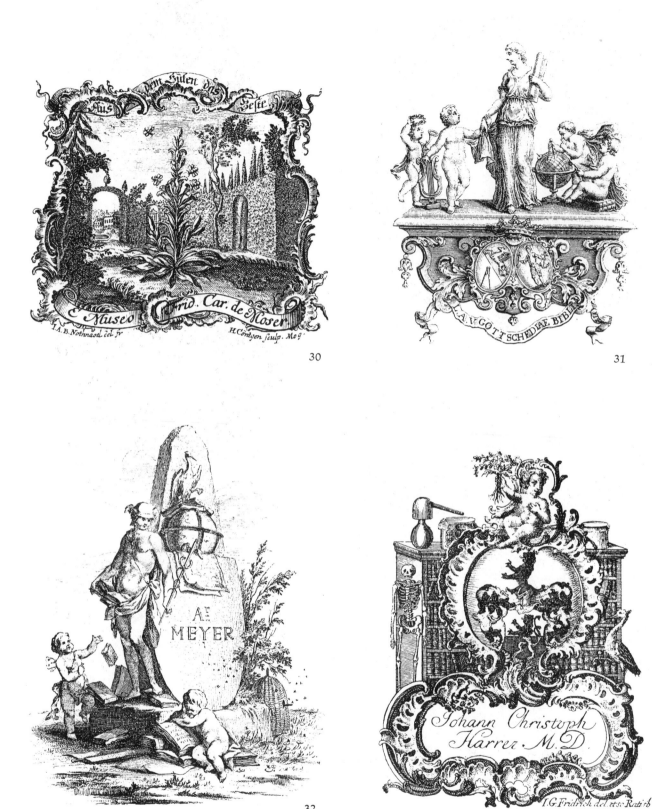

30: J. A. B. Nothnagel (for Friedrich Karl von Moser). 31: Johann Michael Stock (for Luise Gottsched). 32: Johann Wilhelm Meil (for Alexander Meyer). 33: Johann Georg Fridrich.

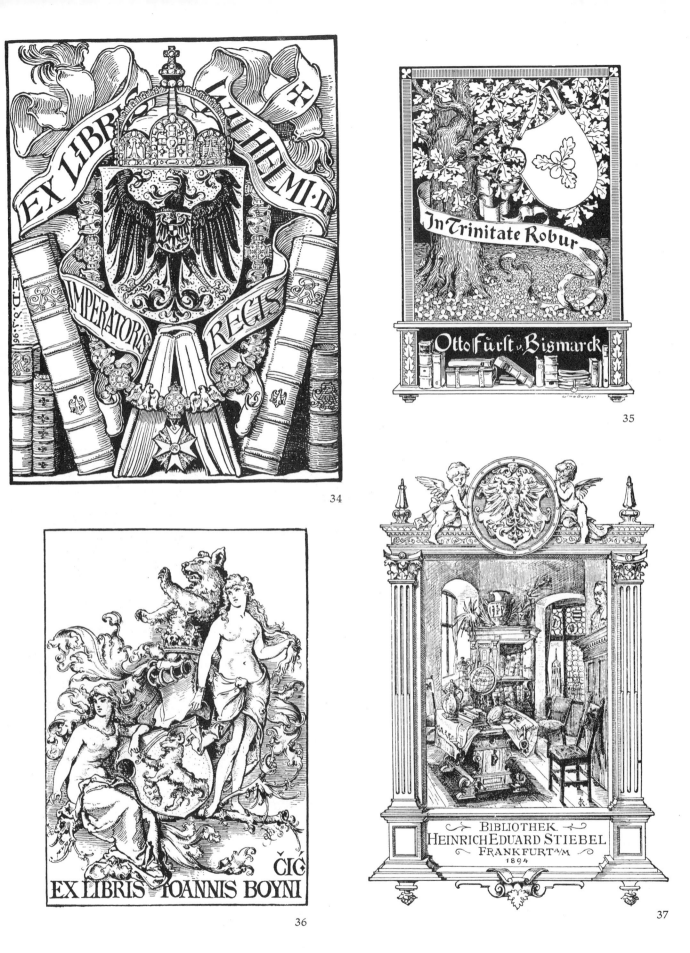

34: Emil Doepler (for Kaiser Wilhelm II). 35: Lina Burger (for Prince Otto von Bismarck). 36 & 37: Anonymous.

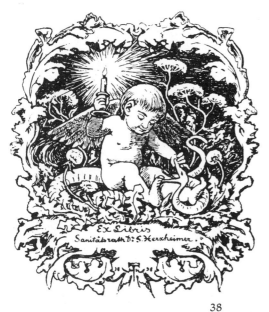

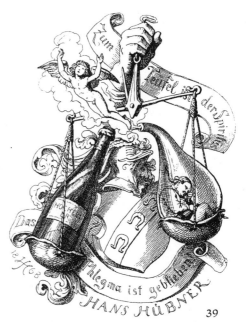

38

39

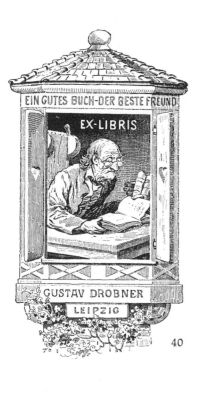

41

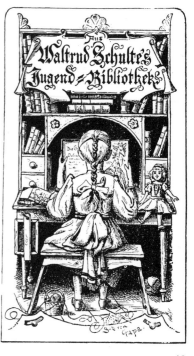

40

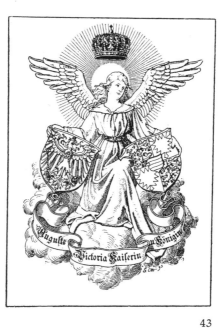

42

43

38: Hans Thoma (for Dr. S. Herscheimer). 39: Julius Hübner (for Hans Hübner).
40: Hermann Feldmann. 41: Ludwig Richter (for Prof. Otto Jahn). 42: Walter
Schulte von Brühl. 43: Anonymous (for the Empress of Germany).

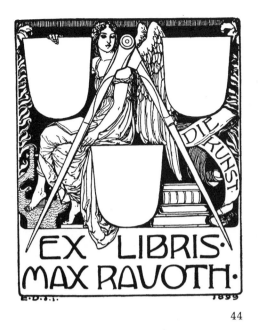

EX LIBRIS·
MAX RAVOTH·

44

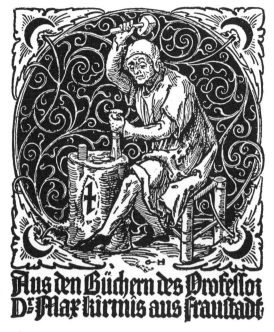

45

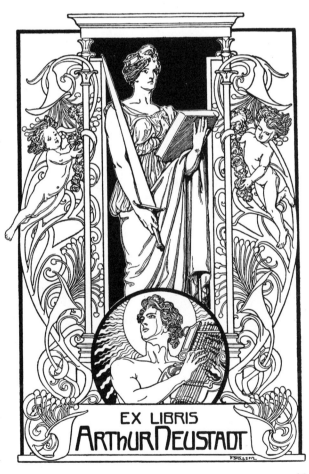

EX LIBRIS
ArthuR NEUSTADt

46

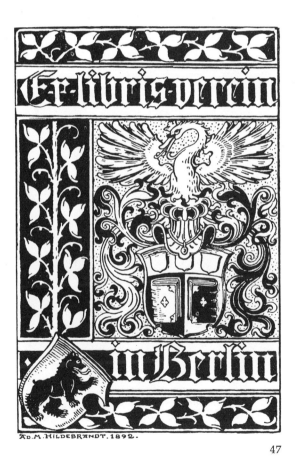

47

44: Emil Doepler. 45: Otto Hupp. 46: Franz Stassen. 47: Adolf M. Hildebrandt.

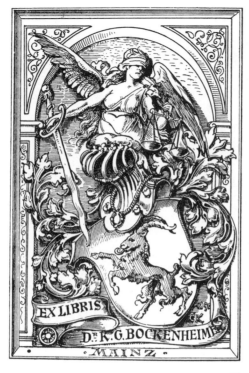

48

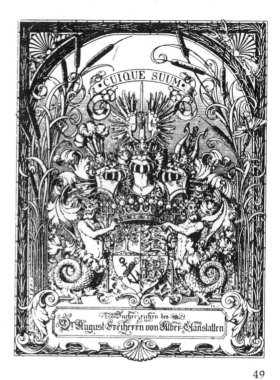

49

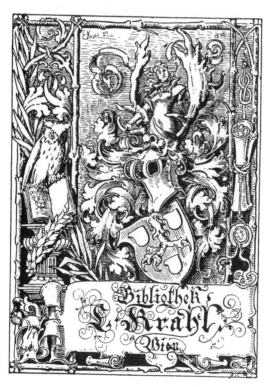

50

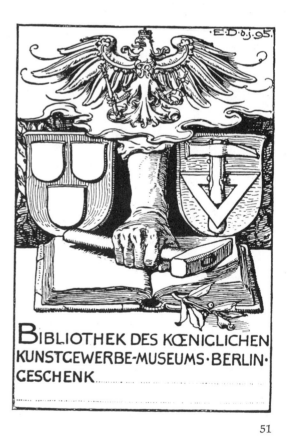

51

48: Clemens Kissel. 49 & 50: E. Krahl. 51: Emil Doepler (for the Library of the Royal Crafts Museum, Berlin).

52-56: Josef Sattler (54, owner unknown; 55, for the Convent of Saint Leonard).

57

58

59

60

61

57: Adolf M. Hildebrandt. 58: Bernhard Wenig. 59: Emil Doepler (for Friedrich Warnecke). 60: R. Sturtzkopf. 61: Georg Barlösius.

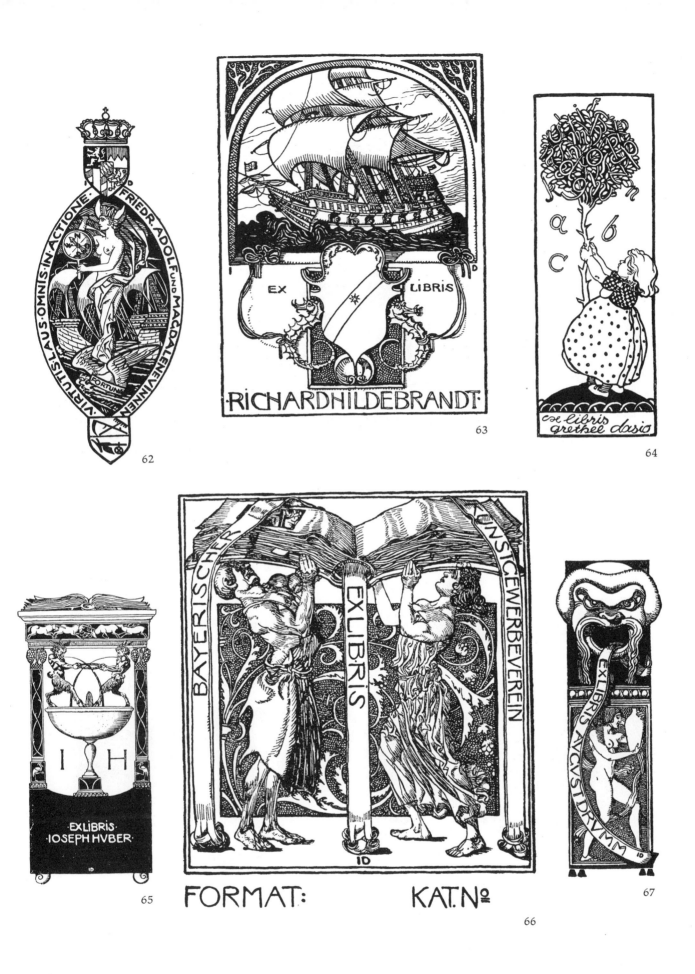

62-67: Julius Diez (66, for the Bavarian Crafts Association).

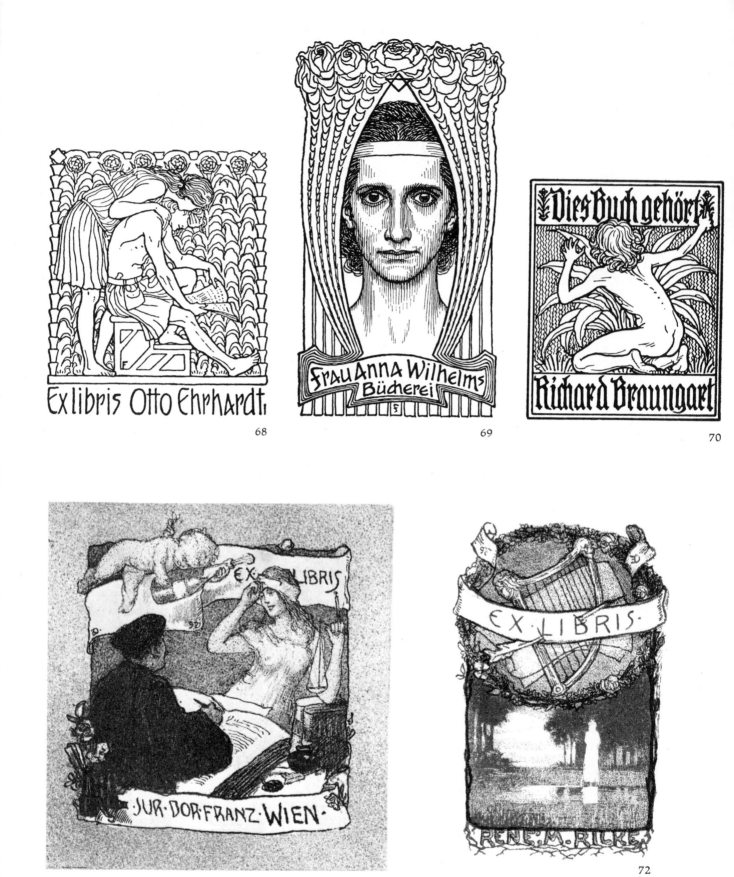

68-70: Hugo Höppener-Fidus. 71 & 72: Emil Orlik.

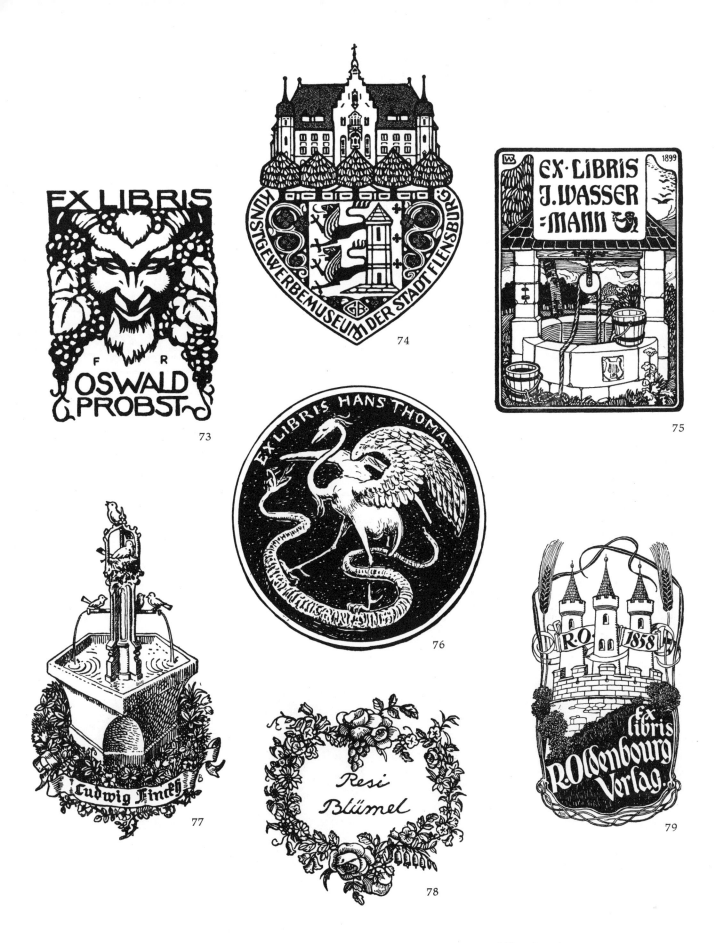

73: Fritz Reinhardt. 74: Georg Belwe (for the Crafts Museum of Flensburg). 75:
Bernhard Wenig. 76: Hans Thoma. 77 & 78: Otto Blümel. 79: Maximilian Josef
Gradl (for R. Oldenbourg, Publishers).

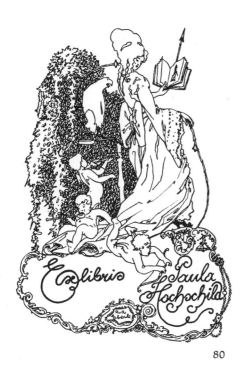

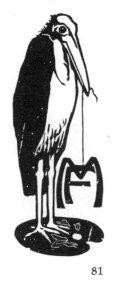

81

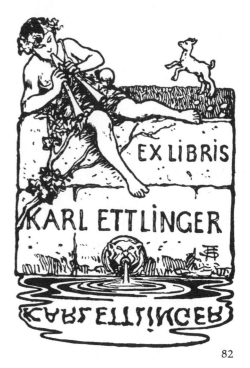

80

82

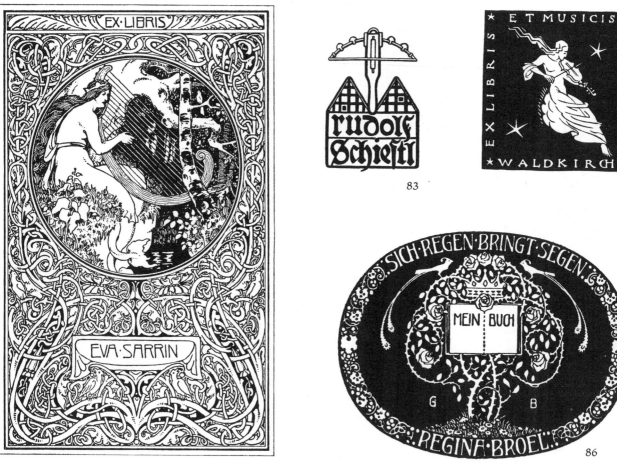

85

83

84

86

80: Rudolf Eberle. 81: Fritz Mock (for himself). 82: Arpad Schmidhammer. 83: Rudolf Schiestl. 84: Ludwig Enders. 85: R. Sarrin. 86: Georg Broël.

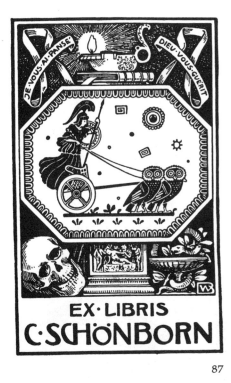

EX·LIBRIS
C·SCHÖNBORN

87

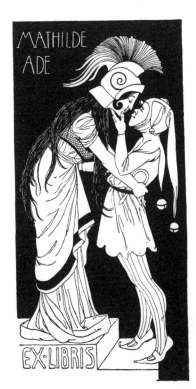

EX LIBRIS

FRANZ
VON
STVCK

88

89

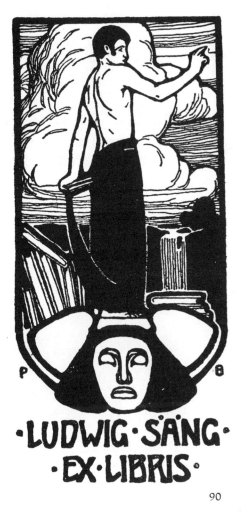

·LUDWIG·SANG·
·EX·LIBRIS·

90

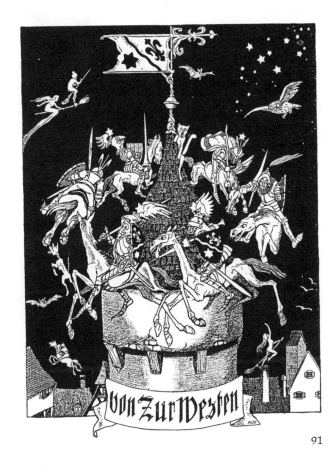

91

87: Bernhard Wenig. 88: Franz von Stuck. 89: Mathilde Ade. 90: Paul Bürck.
91: Mathilde Ade.

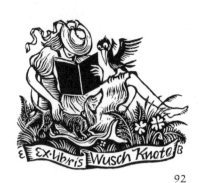

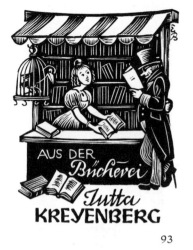

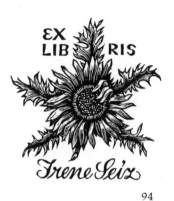

92

93

94

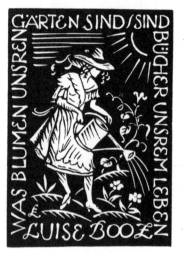

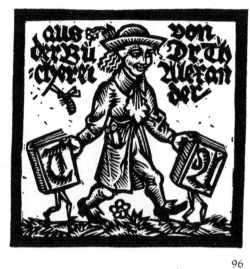

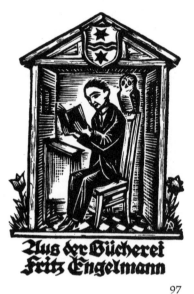

95

96

97

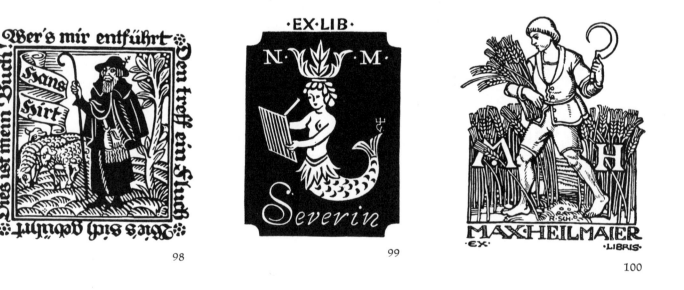

98

99

100

92-94: Ellen Beck. 95: Ludwig Enders. 96: Hans Halm. 97: Hans Pape. 98: Ludwig Enders. 99: Ernst Göhlert. 100: Rudolf Schiestl.

JOSEPH BILLESBERGER

101

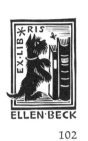

EX·LIB *RIS

ELLEN·BECK

102

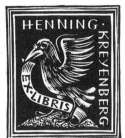

HENNING KREYENBERG

EX LIBRIS

103

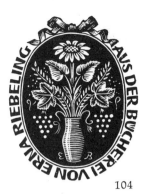

AUS DER BUCHEREI VON ERNA RIEBELING

104

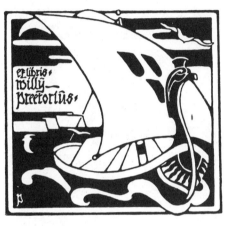

ex libris milly preetorius

105

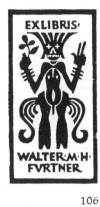

EXLIBRIS·

WALTER·M·H· FVRTNER

106

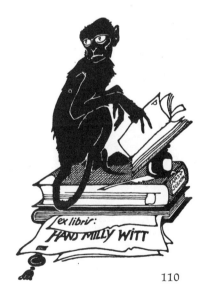

16 P

AUS DER BIBLIOTHEK HELENE FRAENKEL

107

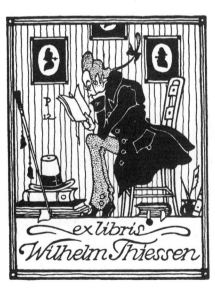

ex libris Wilhelm Thiessen

108

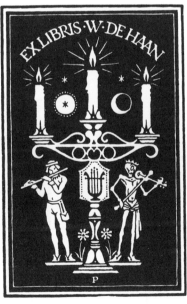

EX LIBRIS·W·DE·HAAN

P

109

ex libris: HANS MILLY WITT

110

101-104: Ellen Beck. 105-110: Emil Preetorius.

111

112

113

114

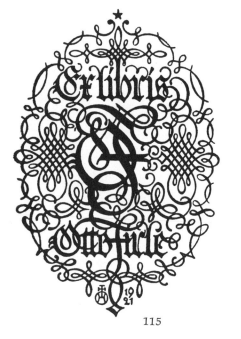

115

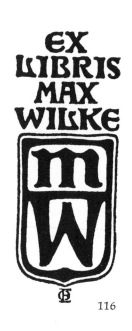

116

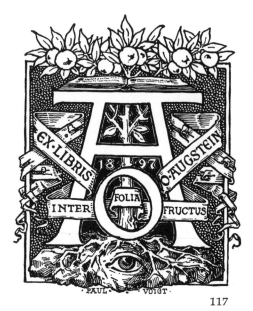

117

118

119

120

121

111-114: Fritz Helmut Ehmcke. 115: Hans Thaddäus Hoyer. 116: Otto Eckmann.
117: Paul Voigt. 118: Hans Thaddäus Hoyer. 119: Ernst Aufseeser. 120: Walter
Tiemann. 121: Paul Voigt.

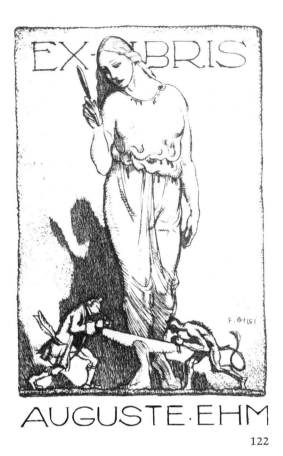

AUGUSTE·EHM

122

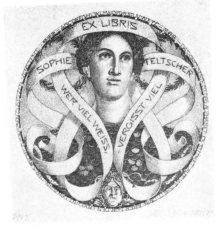

123

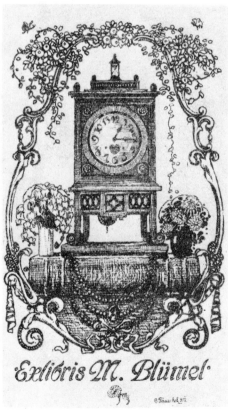

124

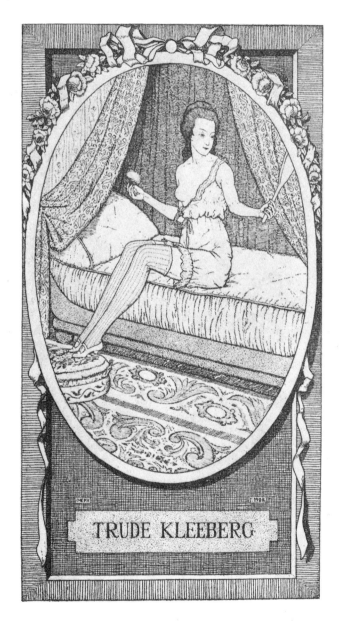

TRUDE KLEEBERG

125

122: Fritz Gilsi. 123: Alfred Cossmann. 124: Otto Tauschek. 125: Martin E. Philipp.

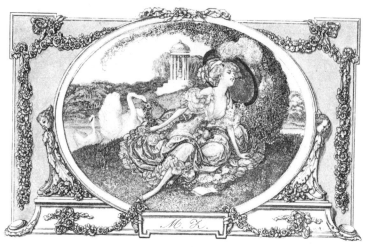

126

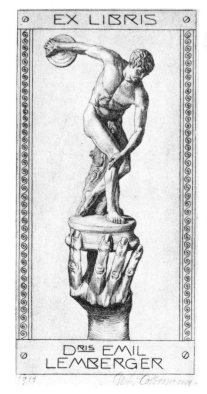

127

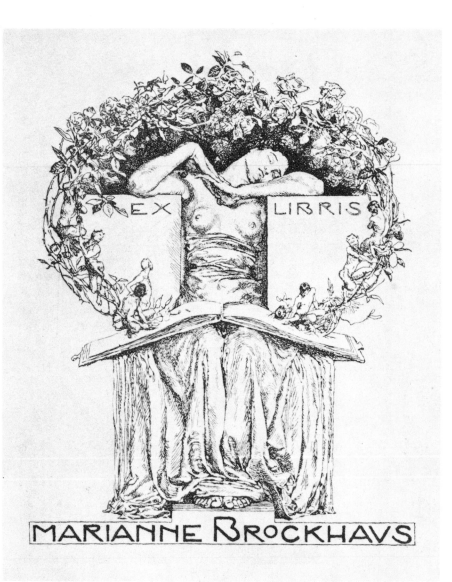

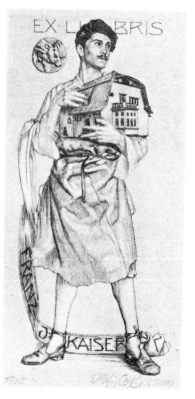

128

129

126: Franz von Bayros (owner unknown). 127: Alfred Cossmann. 128: Otto Greiner. 129: Alfred Cossmann.

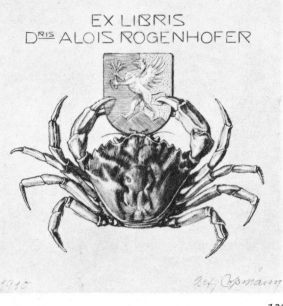

EX LIBRIS
D^RIS ALOIS ROGENHOFER

130

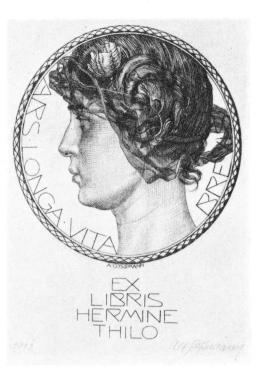

ARS LONGA VITA BREVIS

EX
LIBRIS
HERMINE
THILO

131

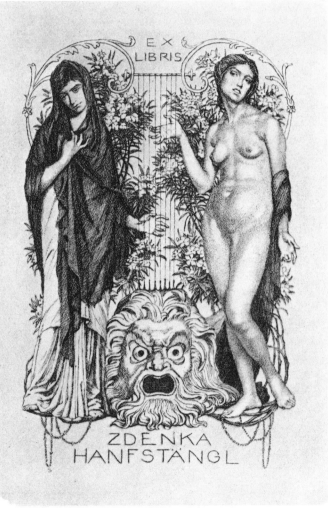

EX LIBRIS

ZDENKA
HANFSTÄNGL

132

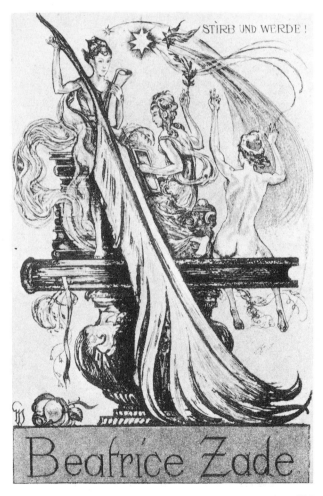

STIRB UND WERDE!

Beatrice Zade

133

130 & 131: Alfred Cossmann. 132: Sigmund Lipinsky. 133: Otto Weigel.

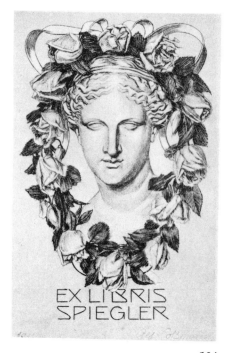

134

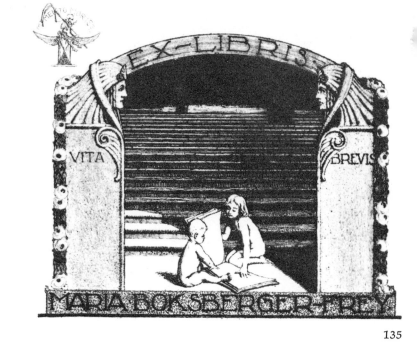

135

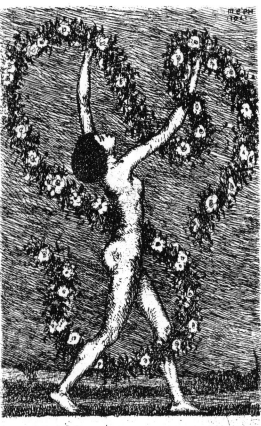

136

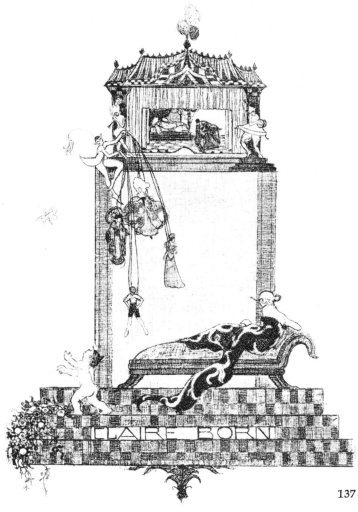

137

134: Alfred Cossmann. 135: Conrad Strasser. 136: Martin E. Philipp. 137: Emma Bachrich.

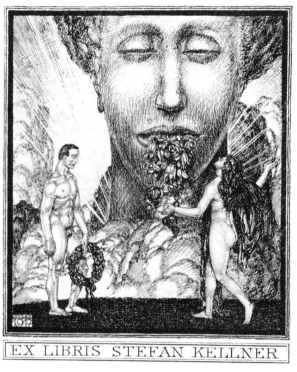

EX LIBRIS STEFAN KELLNER

138

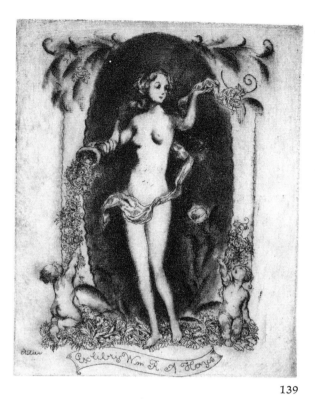

Exlibris Wm. A. A. Hays

139

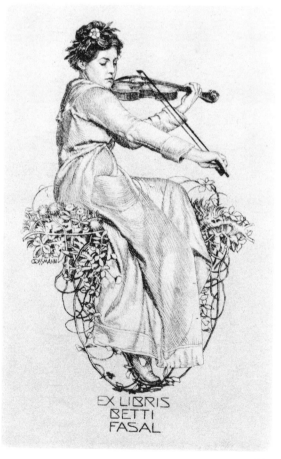

EX LIBRIS
BETTI
FASAL

140

141

138: Divery. 139: Erhard Amadeus-Dier. 140: Alfred Cossmann. 141: Max Klinger.

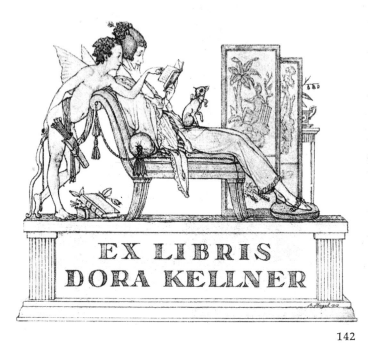

142

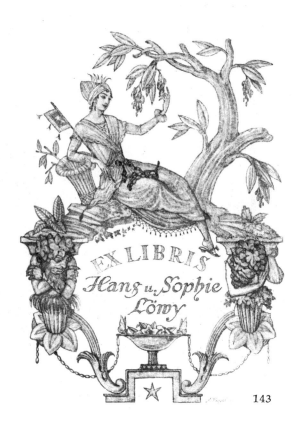

143

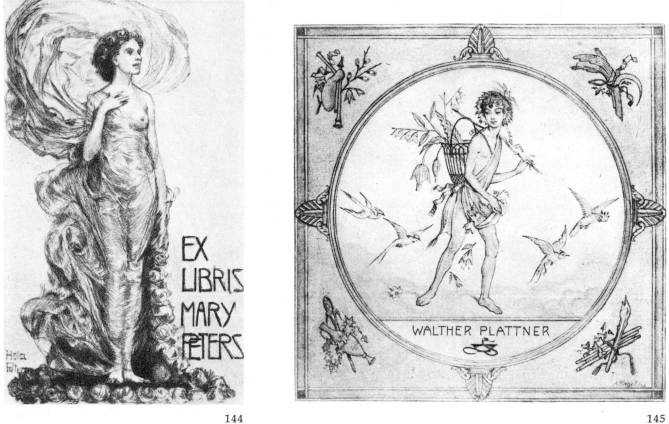

144

145

142 & 143: Alfred Hagel. 144: Hela Peters. 145: Alfred Hagel.

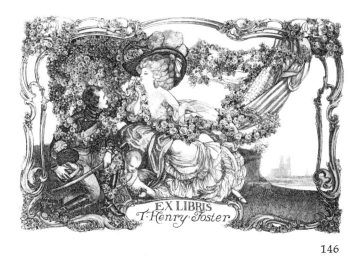

146

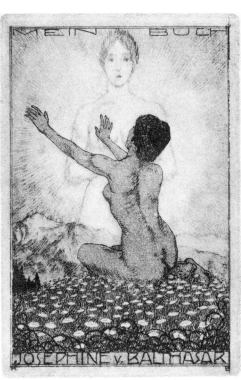

147

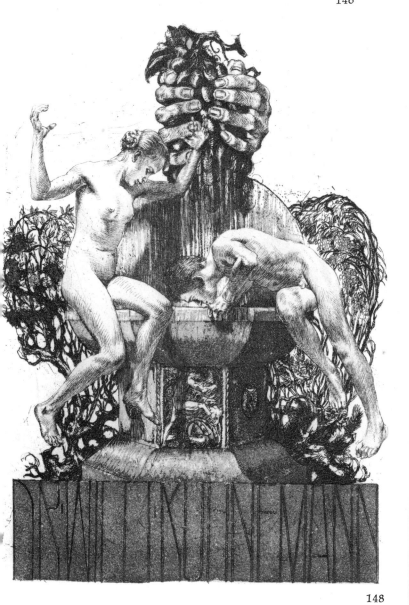

148

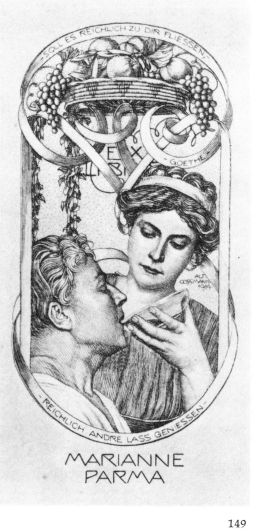

149

146: Franz von Bayros. 147: Walter Blossfeld. 148: Alois Kolb. 149: Alfred Cossmann.

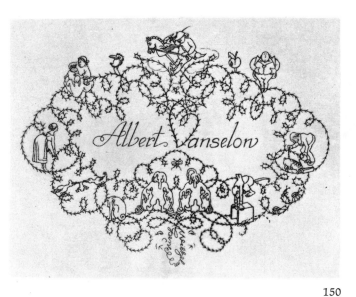

150

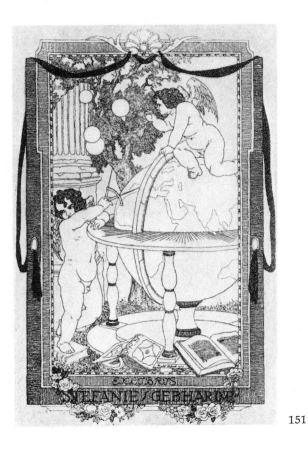

151

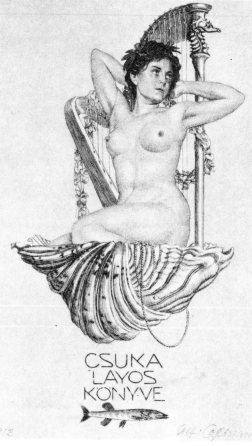

152

153

150: Alfred Cossmann. 151: Rolf Schott. 152: Gustav Traub. 153: Alfred
Cossmann.

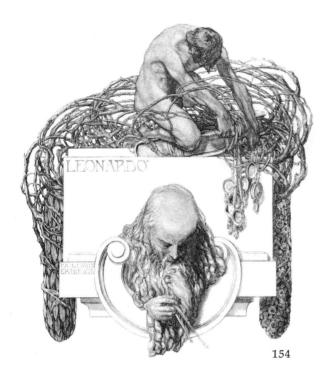

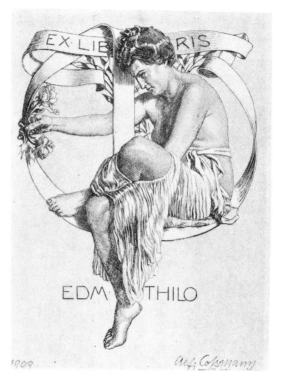

154

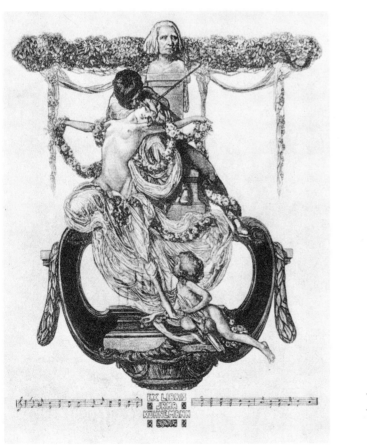

156

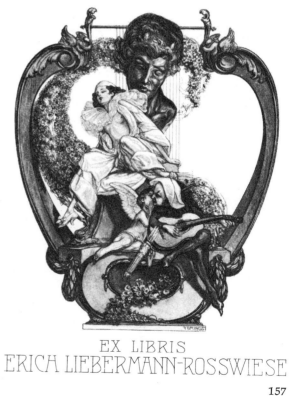

157

155

154: Franz von Bayros. 155: Alfred Cossmann. 156 & 157: Franz von Bayros.

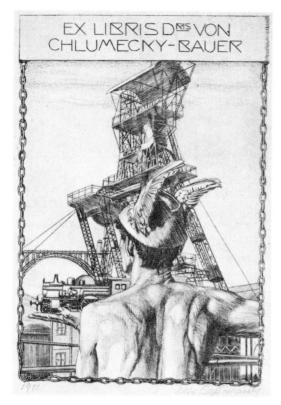

158

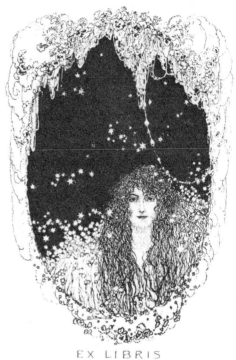

EX LIBRIS
BETTY VAN ESSO

159

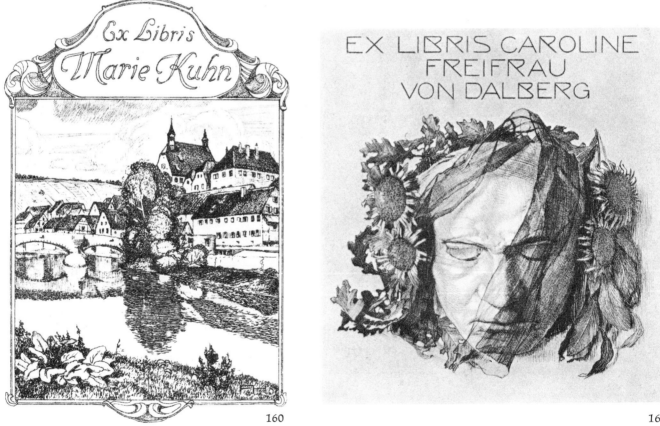

160

161

158: Alfred Cossmann. 159: Eric Schütz. 160: Felix Hollenberg. 161: Alfred Cossmann.

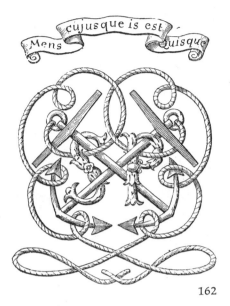

162

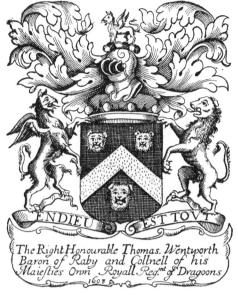

163

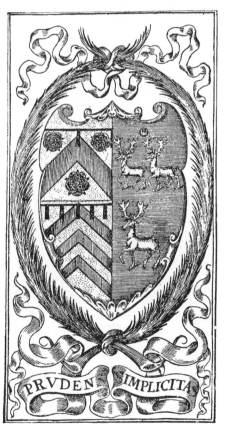

164

165

162: Anonymous (1668, for Samuel Pepys). 163: Anonymous (1698). 164: Anonymous (1655, for Edward Bysshe). 165: Anonymous (1698).

The Right Hon.ble Lady
Henrietta Somerset 1712

166

St John Brodrick of the
Middle Temple Esq.r 1703

167

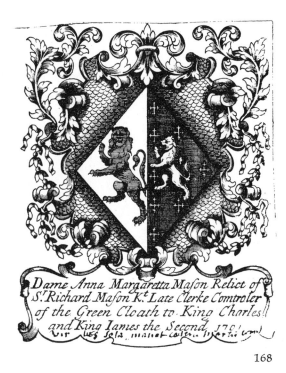

Dame Anna Margaretta Mason Relict of
S.r Richard Mason K.t Late Clerke Comtroler
of the Green Cloath to King Charles
and King Iames the Second 1701

168

Lucius Henry Hibbins
of Gray's Inne Esq.r

169

166-169: Anonymous.

170

171

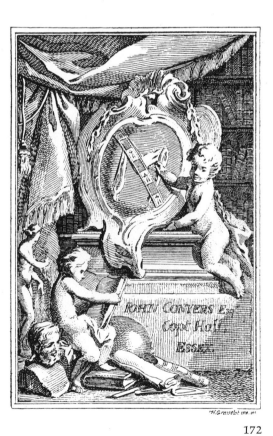

172

173

170 & 171: Anonymous. 172: Henri Gravelot. 173: Anonymous.

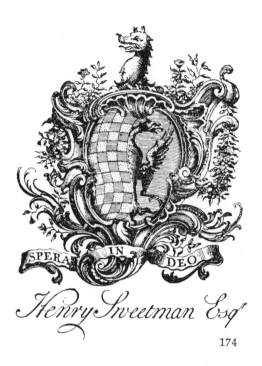

Henry Sweetman Esq

174

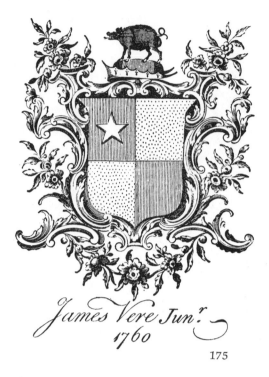

James Vere Jun.
1760

175

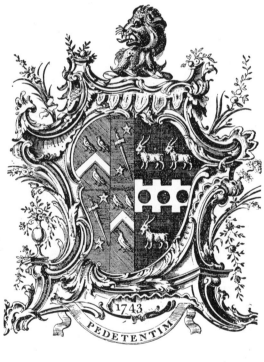

Benjamin Hatley Foote.

176

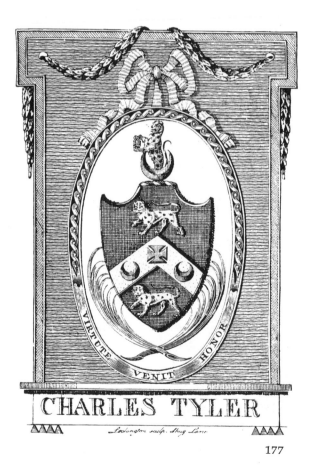

CHARLES TYLER

177

174-176: Anonymous. 177: Lockington.

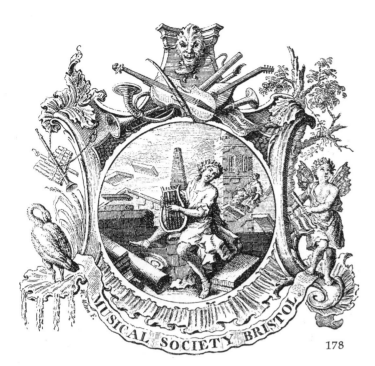

178

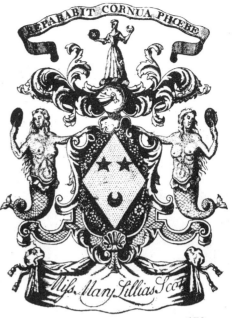

179

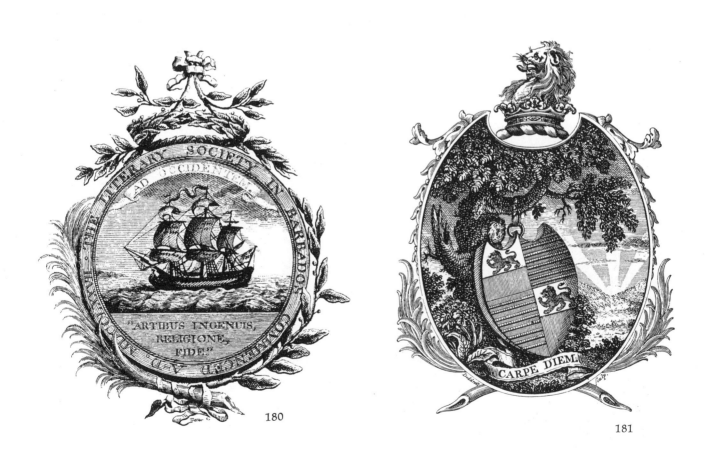

180

181

178: William Milton. 179: Anonymous. 180: Trotter. 181: Doddrell (for J. M. Hall).

The Rev.d
Sam.l Goodenough, L.L.D.

183

Robert Witham, Esq.r
of Springfield in Com. Efsex

I. Pine Sculp:

182

John Fisher,
Lincoln's Inn.

184

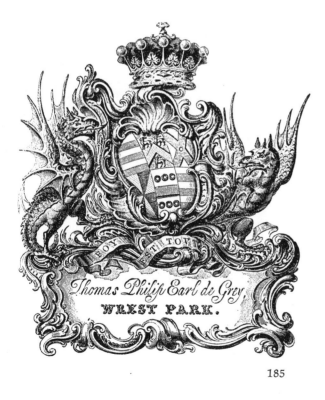

Thomas Philip Earl de Grey,
WREST PARK.

185

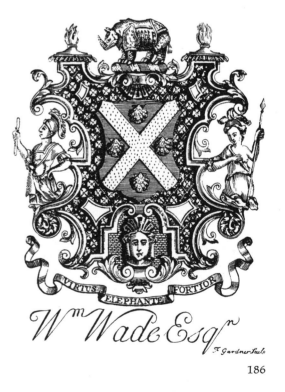

W.m Wade Esq.r

F. Gardner Sculp

186

182: John Pine. 183–185: Anonymous. 186: F. Gardner.

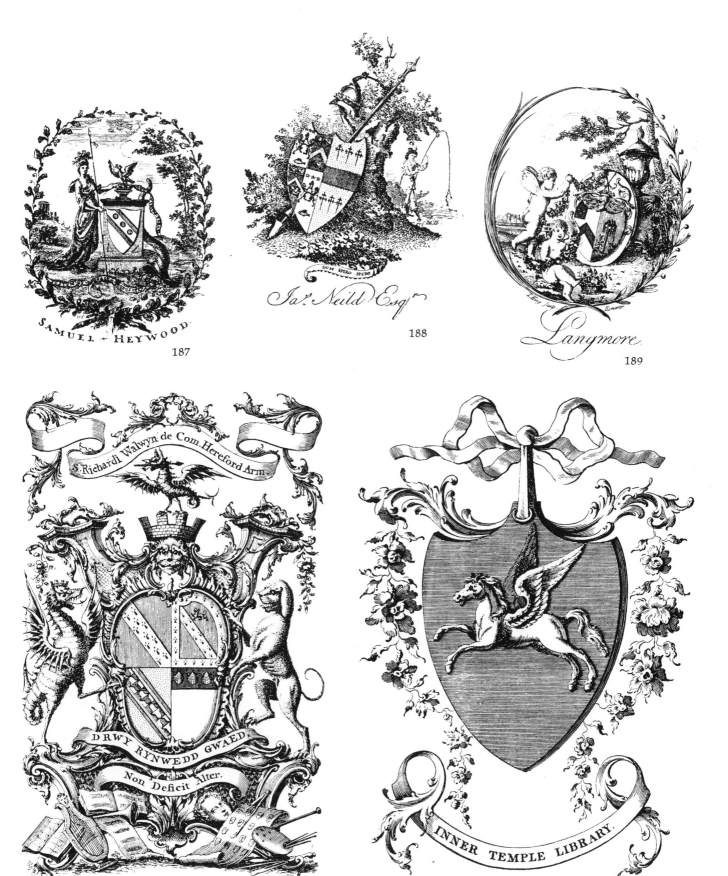

SAMUEL ~ HEYWOOD.

187

Ja. Neild Esq.

188

Langmore

189

S. Richardi Walwyn de Com. Hereford Arm.

DRWY RYNWEDD GWAED.

Non Deficit Alter.

W. H. Toms sc.

190

INNER TEMPLE LIBRARY.

Ja. Kirk del. et sc.

191

187: William Henshaw. 188: Anonymous. 189: T. King. 190: William Henry Toms. 191: James Kirk.

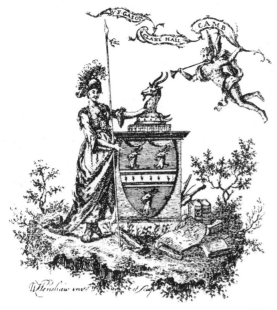

192

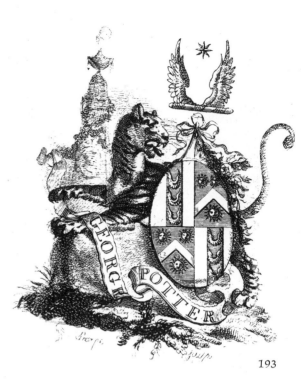

193

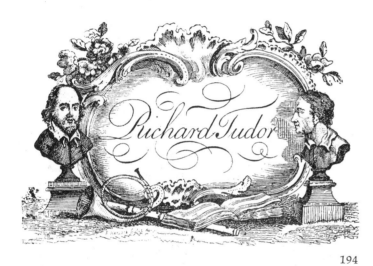

194

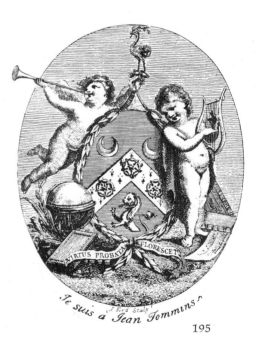

195

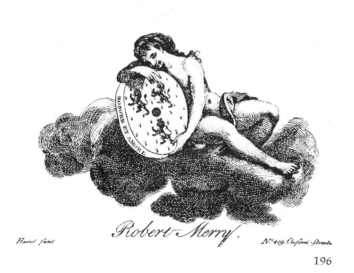

196

192: William Henshaw. 193: William Sharpe. 194: Robert Hancock. 195: J. Ford. 196: Hand.

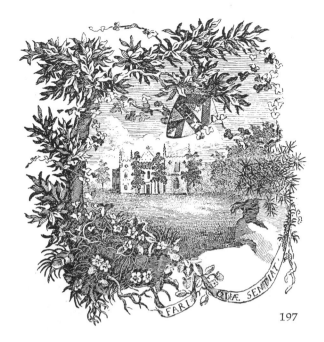

197

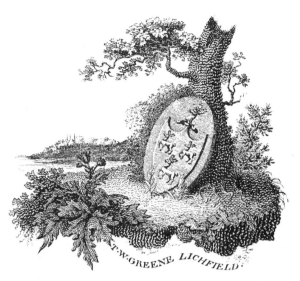

198

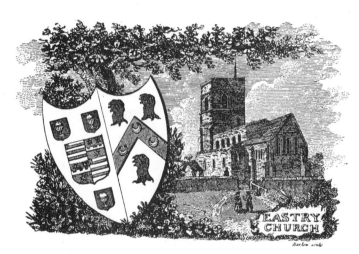

199

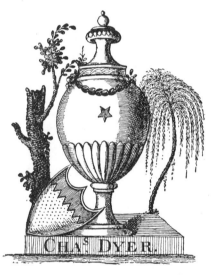

200

201

202

197: Anonymous (for Horace Walpole). 198: John Pye. 199: Barlow (for William Boteler).
200: Anonymous. 201 & 202: Thomas Bewick.

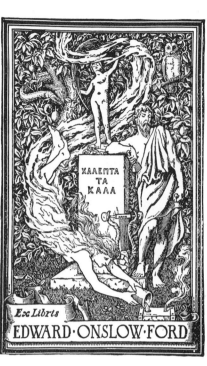

203

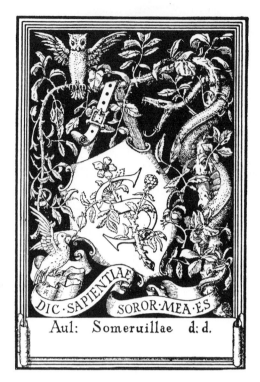

204

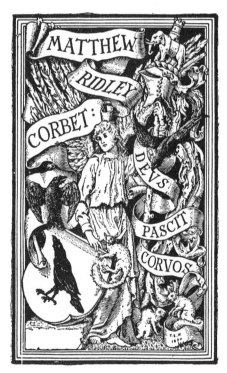

205

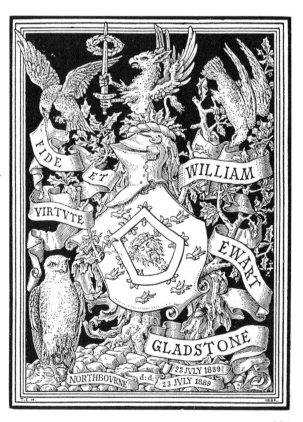

206

203-206: Thomas Erat Harrison (204, for Somerville Hall, Oxford).

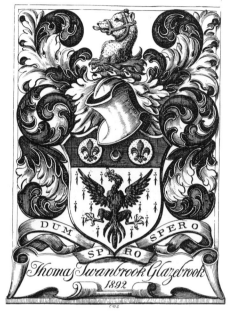

207

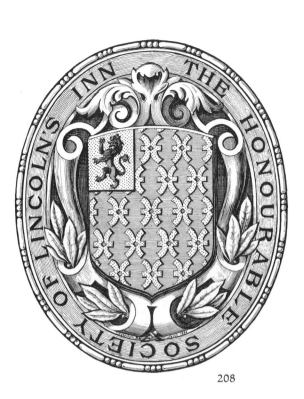

208

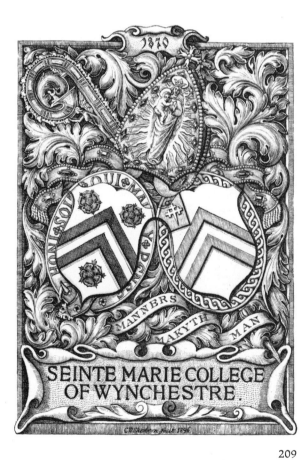

209

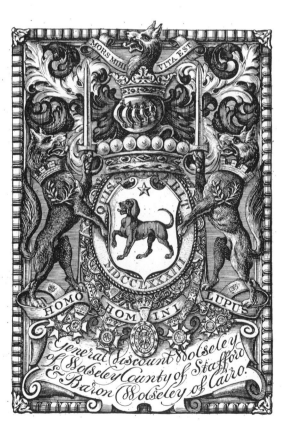

210

207-210: Charles William Sherborn.

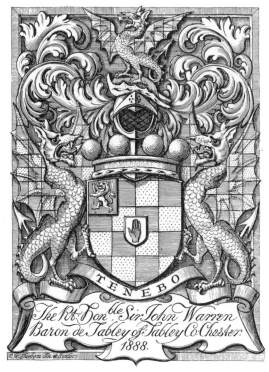

211

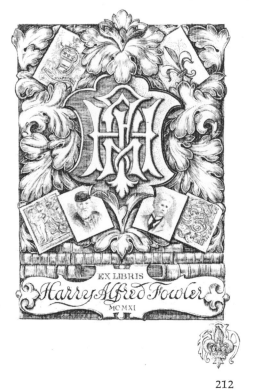

212

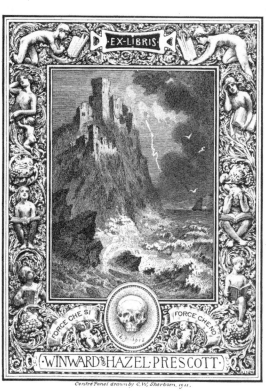

213

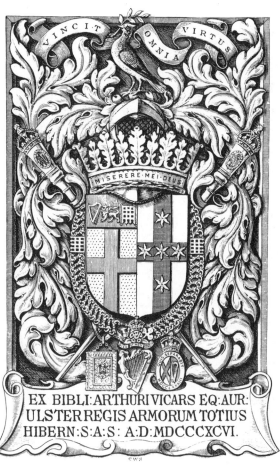

214

211-214: Charles William Sherborn (214, for Sir Arthur Vicars).

215

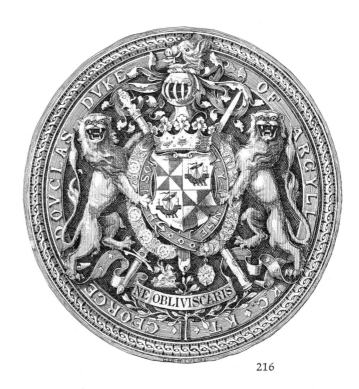

216

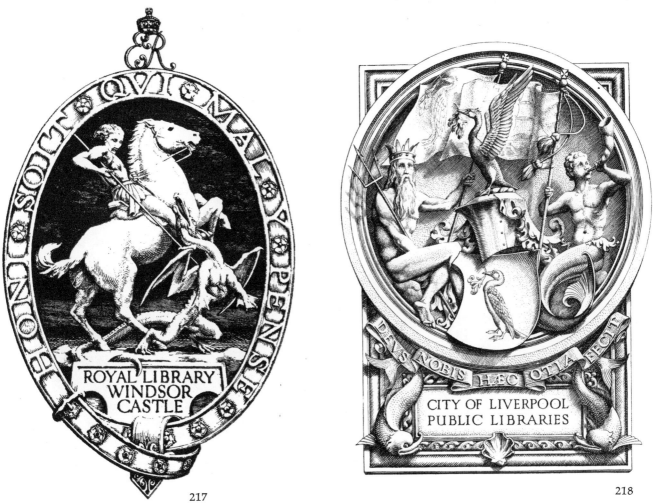

217

218

215 & 216: George W. Eve (215, owner unknown; 216, for the Duke of Argyll).
217 & 218: Stephen Gooden.

219

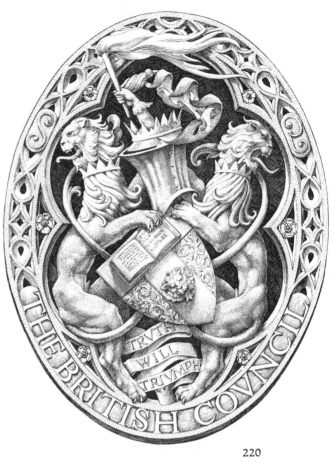

220

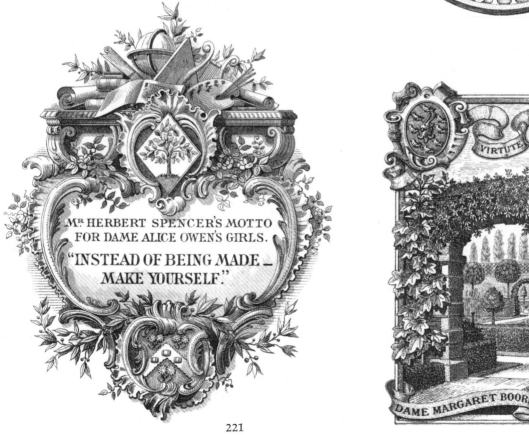

221

222

219: William Phillips Barrett. 220: Stephen Gooden. 221 & 222: Thomas Moring.

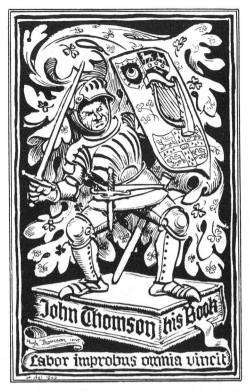

223

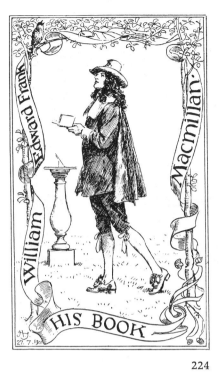

224

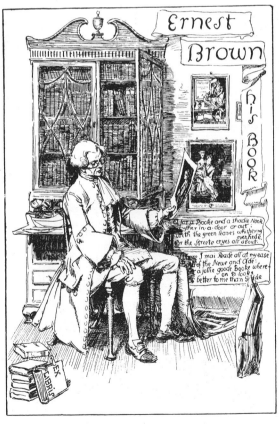

225

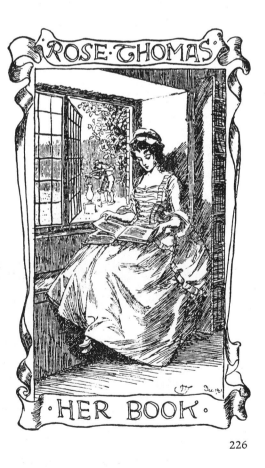

226

223-226: Hugh Thomson.

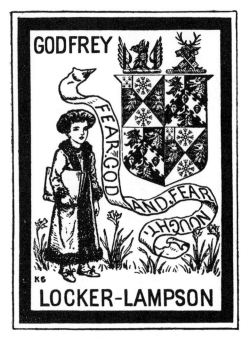

227

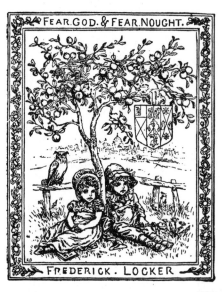

228

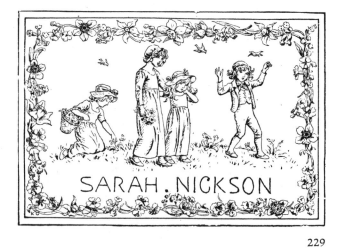

229

230

231

232

227-230: Kate Greenaway. 231: Marion Reid. 232: Walter Crane.

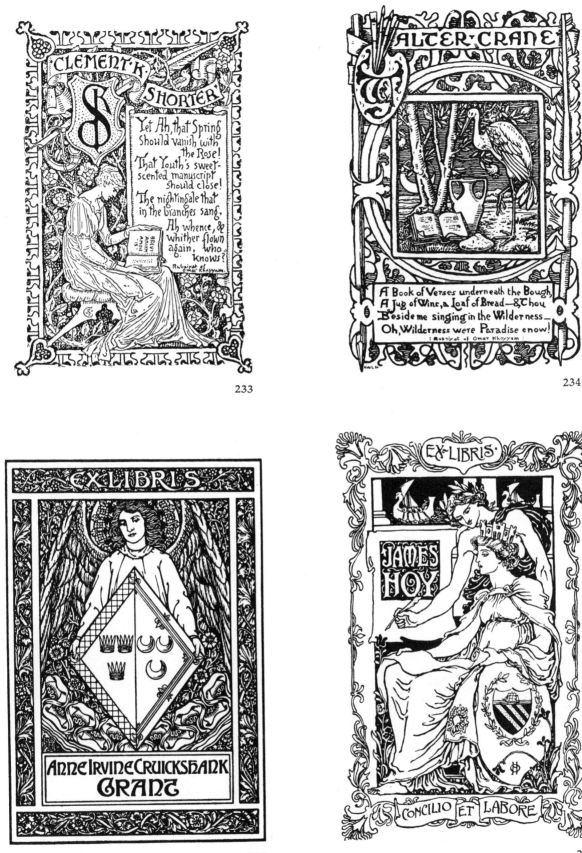

233 & 234: Walter Crane. 235: John Sutherland. 236: Henry Ospovat.

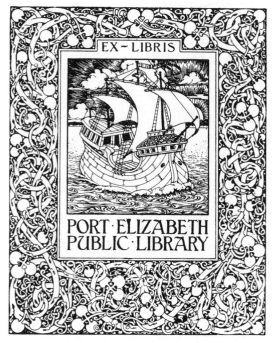

237

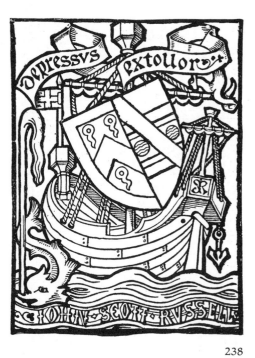

238

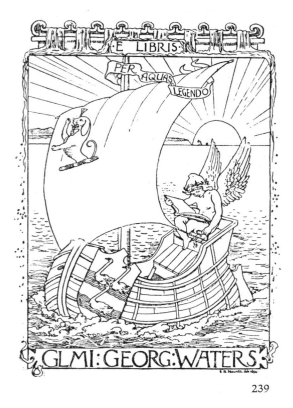

239

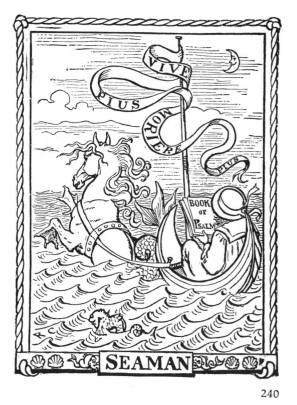

240

237: F. Pickford Marriott. 238: John Leighton ("Luke Limner"). 239: E. R. Hughes. 240: Randolph Caldecott.

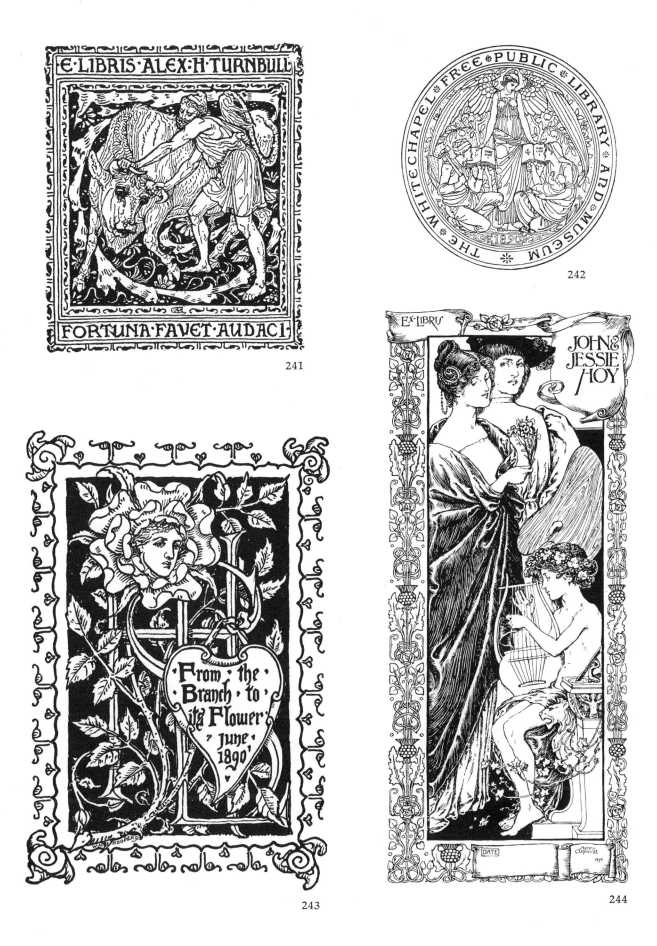

241-243: Walter Crane (243, for May Morris). 244: Henry Ospovat.

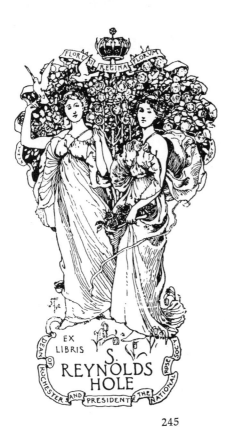

245

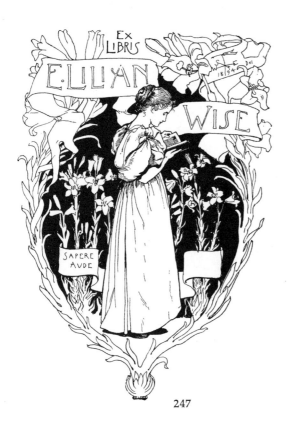

247

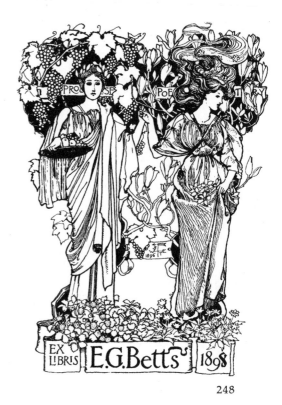

248

245-248: Joseph Walter West.

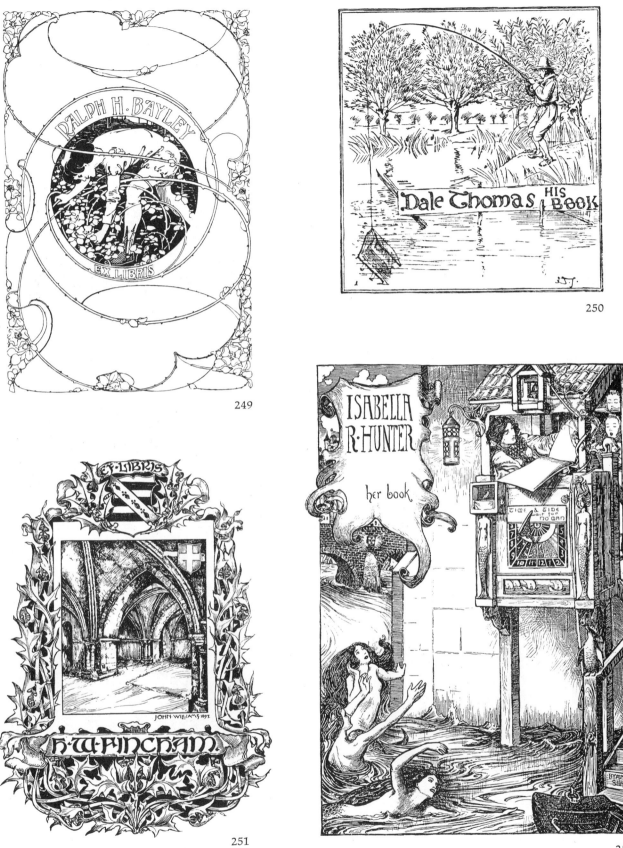

249: Ralph H. Bayley. 250: Hugh Thomson. 251: John Williams. 252: Byam
Shaw.

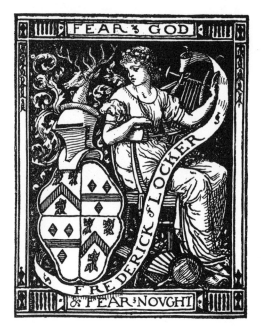

253

254

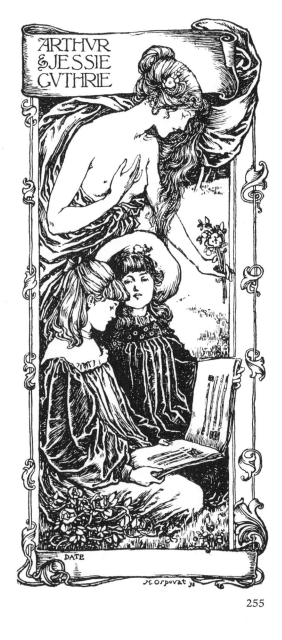

255

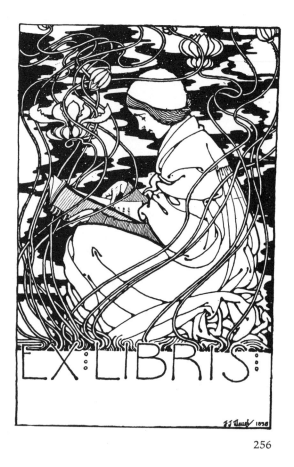

256

253: W. R. Weyer. 254: Walter Crane. 255: Henry Ospovat. 256: J. J. Waugh
(owner unknown).

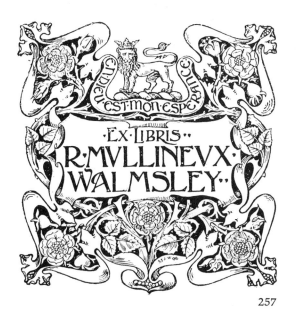

257

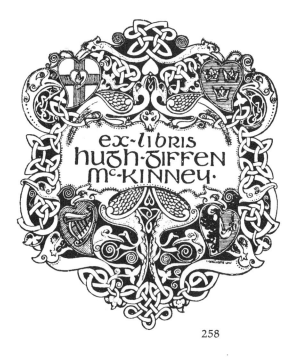

258

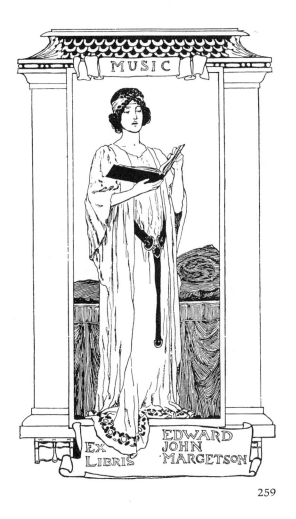

259

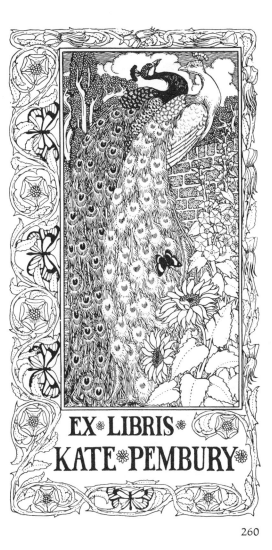

260

257 & 258: John Williams. 259: W. H. Margetson. 260: P. J. Billinghurst.

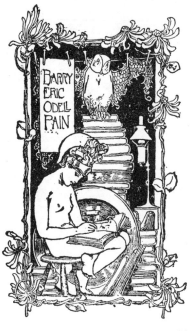

261

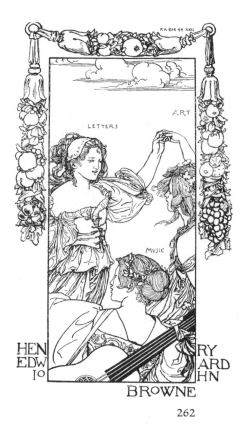

262

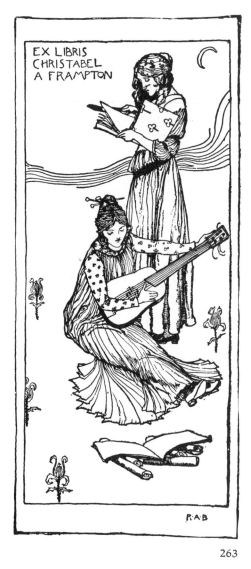

263

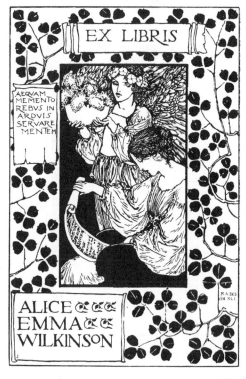

264

261-264: Robert Anning Bell.

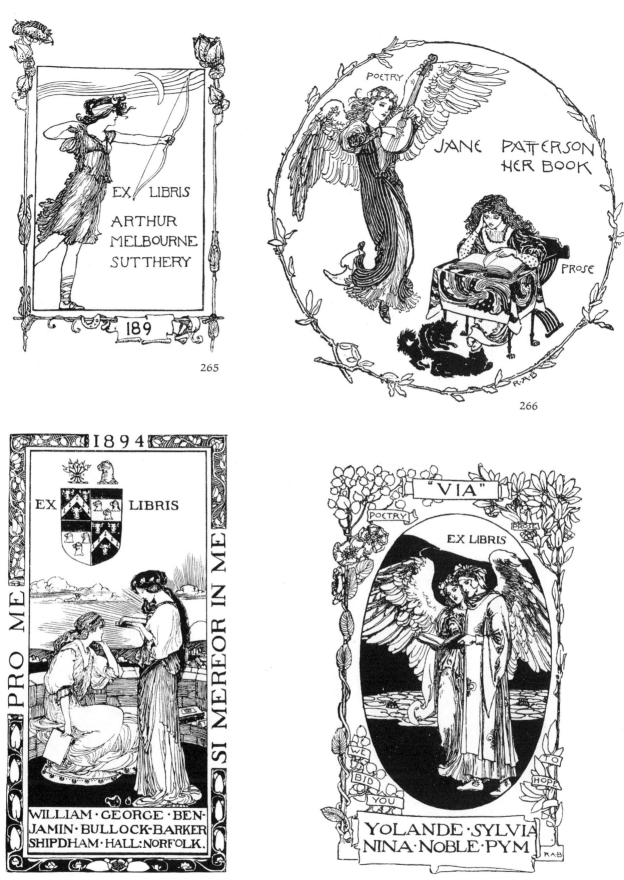

265-268: Robert Anning Bell.

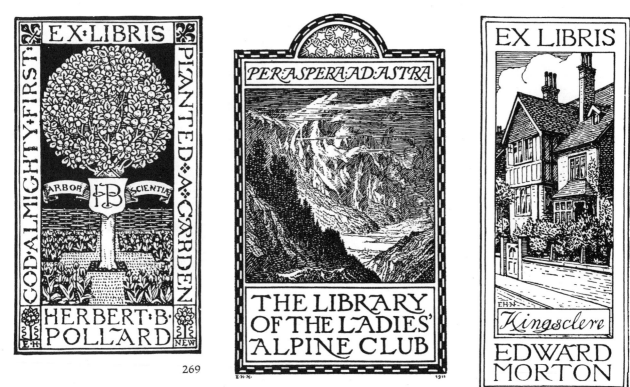

269

270

271

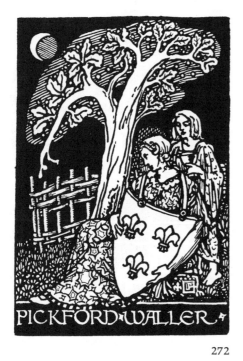

272

273

269-271: Edmund Hort New. 272 & 273: James Guthrie.

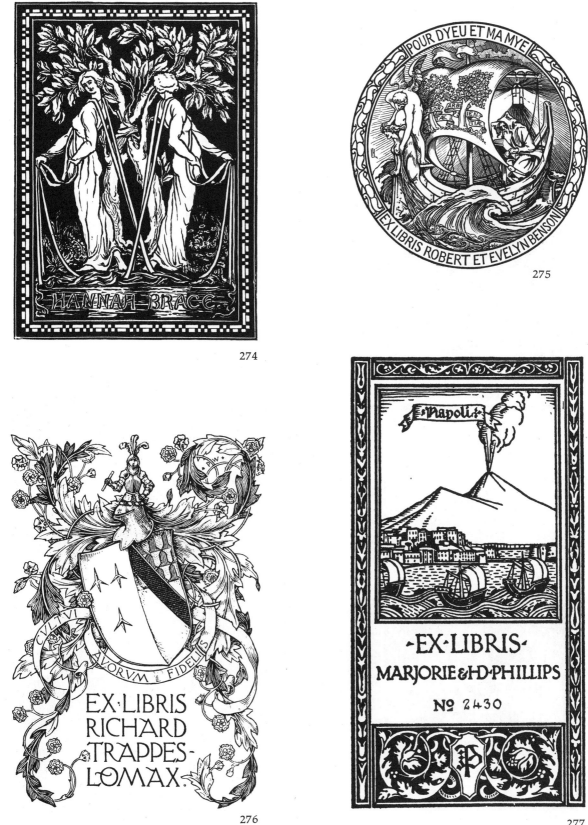

274 & 275: Laurence Housman. 276: Paul Woodroffe. 277: Robert Austin.

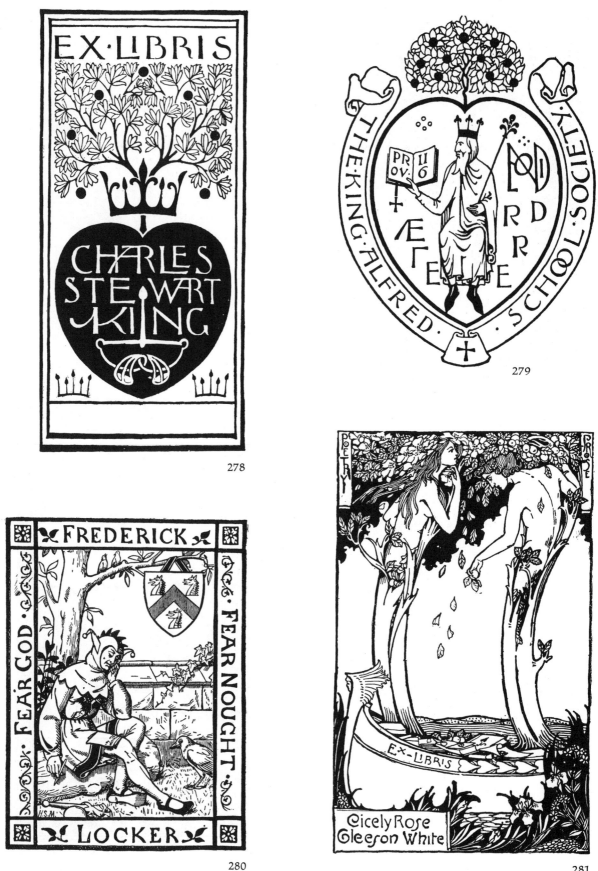

278

279

280

281

278 & 279: Charles F. Annesley Voysey. 280: H. Stacy Marks. 281: Harry
Napper.

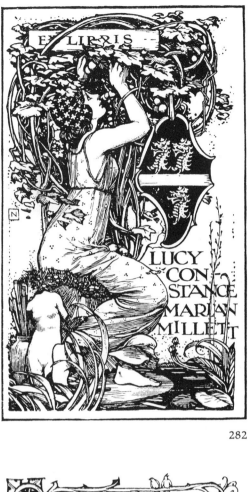

282

283

284

285

282-285: Harold Nelson (283, owner unknown).

HELEN·WILSON
HER·BOOK·····1917·

286

JAMES·H·NEWMAN

287

ESTELL·A
CANZIANI

288

Mario·BORSA

289

286-289: Frank William Brangwyn.

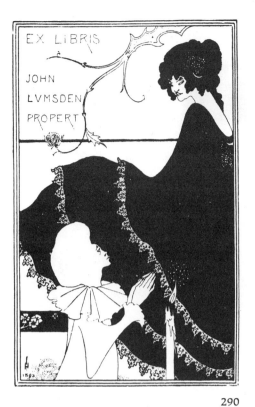

290

291

293

292

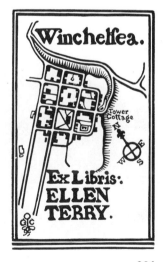

294

295

296

290: Aubrey Beardsley. 291-294: Gordon Craig (292, for himself; 293, for Kitty Downing). 295: William P. Nicholson. 296: Gordon Craig.

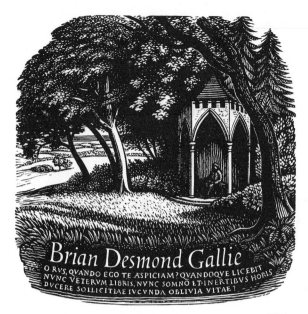

Brian Desmond Gallie

O RVS, QVANDO EGO TE ASPICIAM? QVANDOQVE LICEBIT
NVNC VETERVM LIBRIS, NVNC SOMNO ET INERTIBVS HORIS
DVCERE SOLLICITIAE IVCVNDA OBLIVIA VITAE?

297

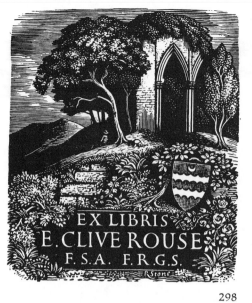

EX LIBRIS
E. CLIVE ROUSE
F.S.A. F.R.G.S.

298

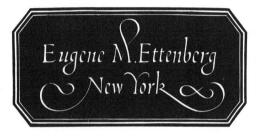

Eugene M. Ettenberg
New York

299

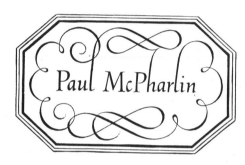

Paul McPharlin

300

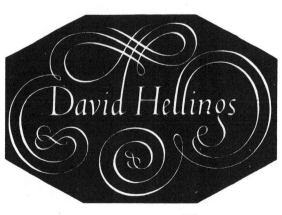

David Hellinos

301

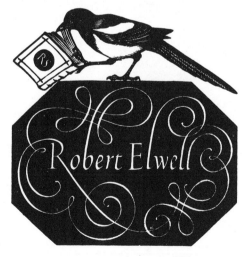

Robert Elwell

302

297-302: Reynolds Stone.

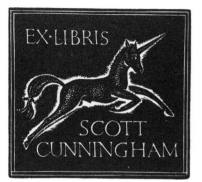

303

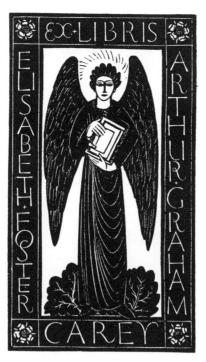

304

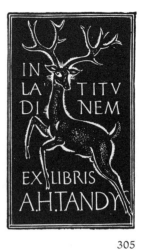

305

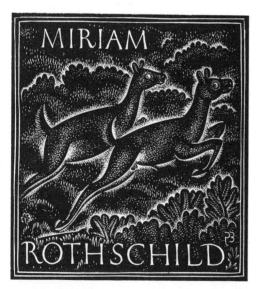

306

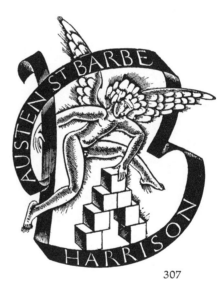

307

308

309

310

311

303–307: Eric Gill. 308–310: Will Carter. 311: Diana Bloomfield.

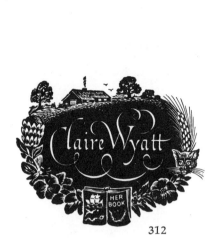

312

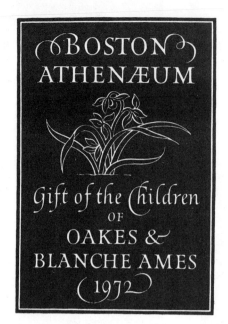

313

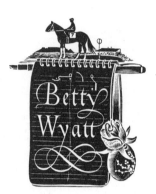

314

315

316

317

318

319

312-316: Leo Wyatt. 317-319: Diana Bloomfield.

320

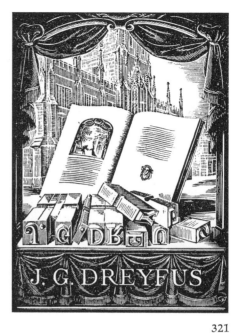

321

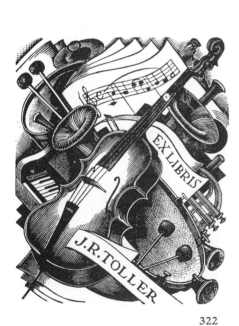

322

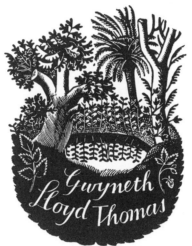

323

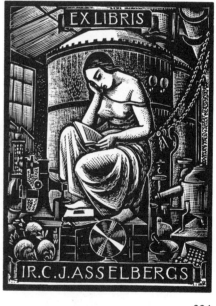

324

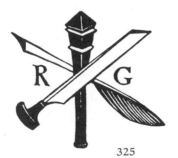

325

320 & 321: Joan Hassall. 322: G. E. Mackley. 323: Eric Ravilious. 324: John Buckland Wright. 325: Robert Gibbings (for himself).

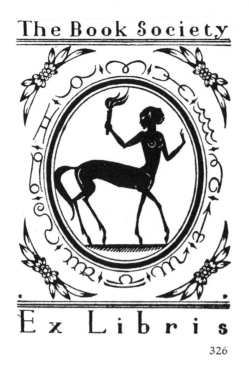

The Book Society

Ex Libris

326

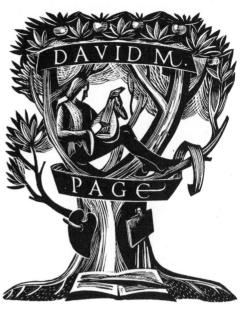

DAVID M. PAGE

327

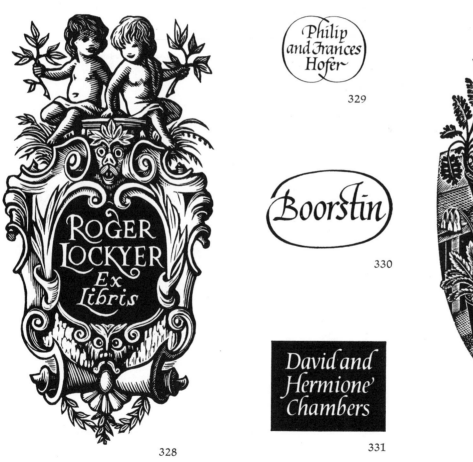

ROGER LOCKYER Ex Libris

328

Philip and Frances Hofer

329

Boorstin

330

David and Hermione' Chambers

331

ROGER BEVAN

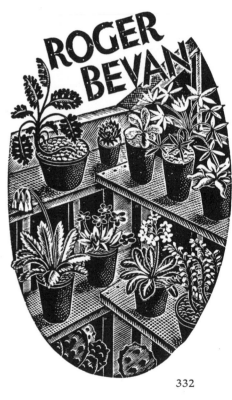

332

326: Edmund Dulac. 327: Peter Reddick. 328: Frank Martin. 329-331: Will Carter. 332: Eric Ravilious.

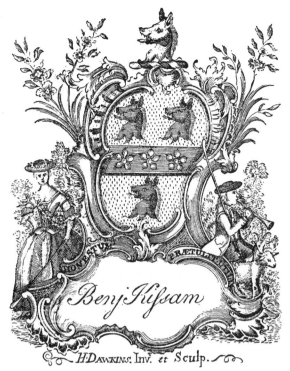

Benj Kissam

333

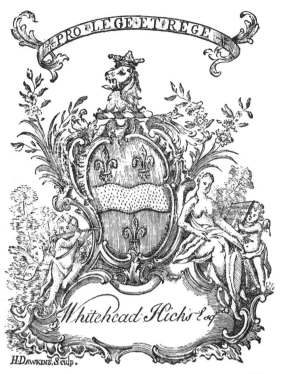

PRO LEGE ET REGE

Whitehead Hicks Esq

334

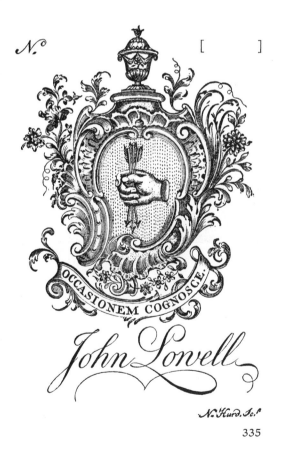

N.º []

OCCASIONEM COGNOSCE

John Lovell

335

AUDACITER

J.H. Erving

336

333 & 334: Henry Dawkins. 335: Nathaniel Hurd. 336: Anonymous.

EXITUS ACTA PROBAT

George Washington

338

LIBERTATEM AMICITIAM RETINEBIS ET FIDEM.

John Adams.

337

John Quincy Adams.

339

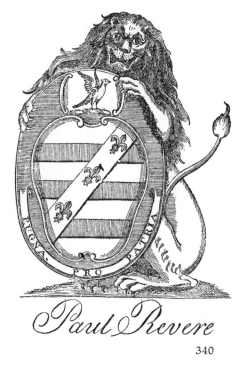

PUGNA PRO PATRIA

Paul Revere

340

Nº

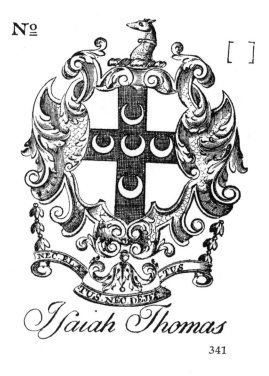

NEC ELE TUS NEC DEJE TUS

[]

Isaiah Thomas

341

337-339: Anonymous. 340 & 341: Paul Revere.

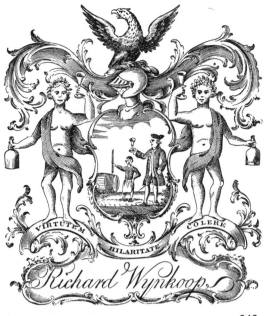

Richard Wynkoop.

342

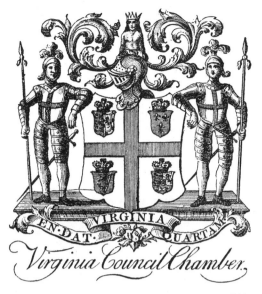

Virginia Council Chamber.

343

344

345

342–344: Anonymous. 345: Elisha Gallaudet.

William Penn Esq. Proprietor
of Pensylvania 1703

346

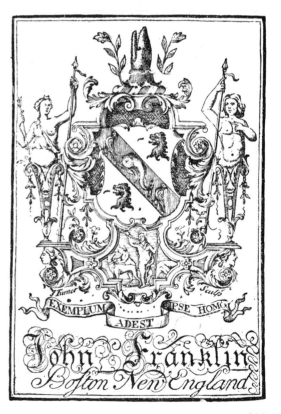

DEPRESSA · RESURGO.

NEVER DESPAIR.

JOHN PINTARD, LL. D.

347

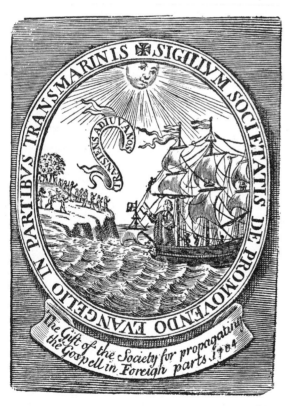

SIGILLVM SOCIETATIS DE PROMOVENDO EVANGELIO IN PARTIBVS TRANSMARINIS

TRANSIENS ADIVVA NOS

The Gift of the Society for propagating
the Gospell in Foreign parts 1704

348

EXEMPLUM ADEST IPSE HOMO

John Franklin
Boston New England

349

346: Anonymous. 347: Alexander Anderson. 348: Anonymous. 349: James Turner.

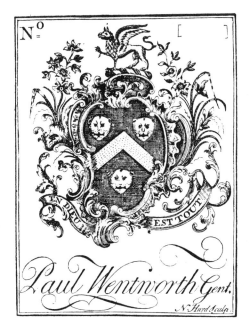

350

351

352

353

350: Nathaniel Hurd. 351: Peter Rushton Maverick. 352 & 353: Amos Doolittle.

Thomas O. Selfridge,

BOSTON,

1799.

354

355

(No. 44)

THE PROPERTY OF THE

Worcester Circulating Library Company.

First Cost, £.0 5 12 7

FINE *for detention,* 4 1/2 per day.

356

Daniel Greenleaf

357

Harrison Gray Otis

358

NUMERUS *152* PRETIUM *Do: 88*

E LIBRIS

THOMÆ HOLT.

359

THE PROPERTY OF

TIMOTHY MANN.

WALPOLE.

Oct.—1810.

360

354-360: Anonymous.

361 & 362: Peter Rushton Maverick. 363: Joseph Callender. 364: Amos Doolittle.

365: James Trenchard. 366: Anonymous. 367: Samuel Harris. 368: Samuel Hill.
369 & 370: Anonymous.

371

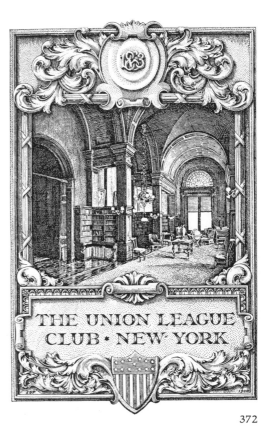

372

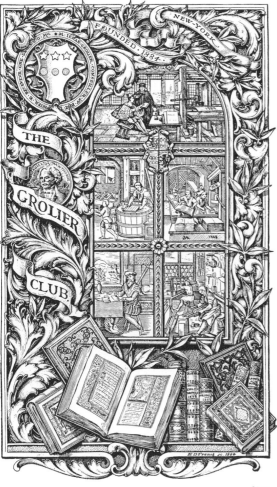

373

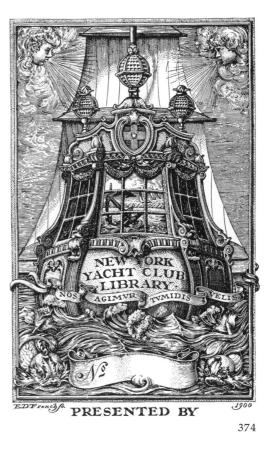

374

371-374: Edwin Davis French.

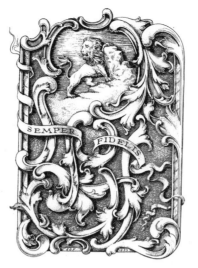

375

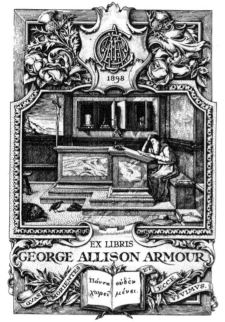

376

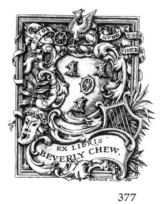

377

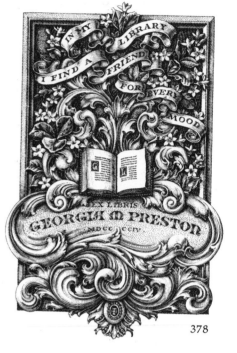

378

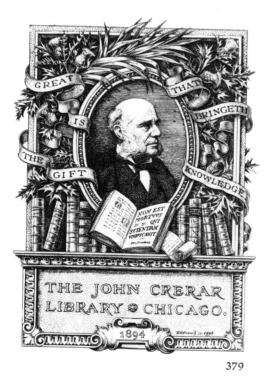

379

380

375-380: Edwin Davis French (375, for L. B. Löwenstein).

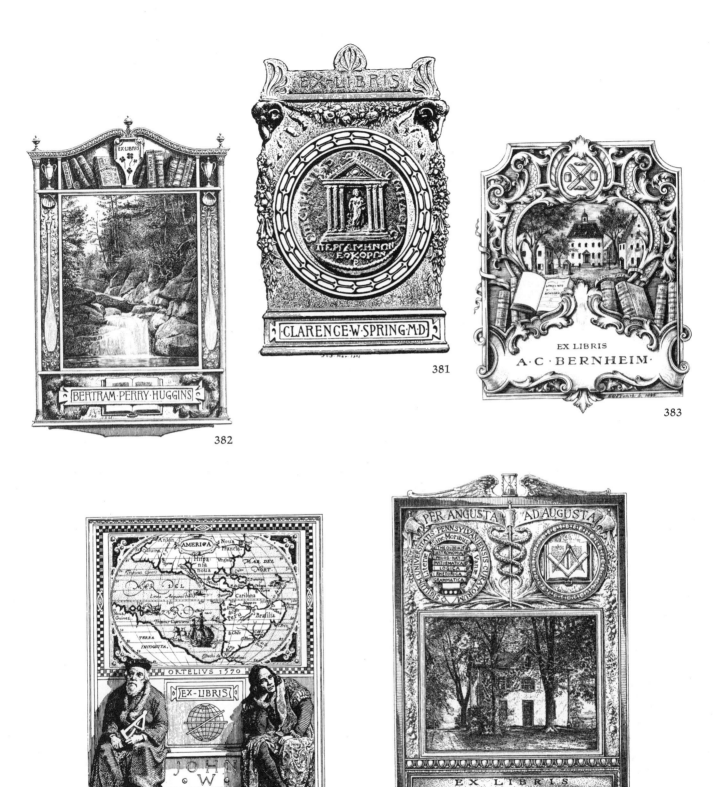

381

382

383

384

385

381 & 382: Sidney L. Smith. 383: Edwin Davis French. 384 & 385: Sidney L. Smith.

UNITED STATES, LATE NINETEENTH AND EARLY TWENTIETH CENTURIES 79

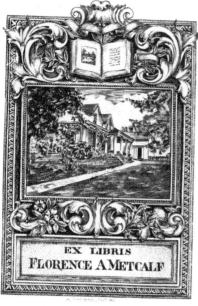

EX LIBRIS
FLORENCE A METCALF

386

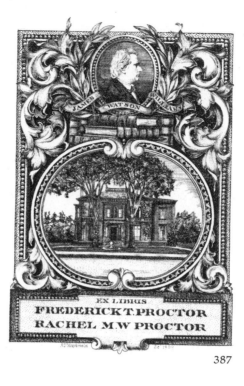

EX LIBRIS
FREDERICK T. PROCTOR
RACHEL M.W. PROCTOR

387

RUDOLPH AND KATY
HOFHEINZ

388

DOMUS ET ORBIS

WOMAN'S CLUB
OF
WISCONSIN

390

EX LIBRIS ZELLA ALLEN DIXSON

391

EX LIBRIS

GEORGE·S·CHAMBLISS

389

386-388: Arthur N. Macdonald. 389-391: J. Winfred Spenceley.

392

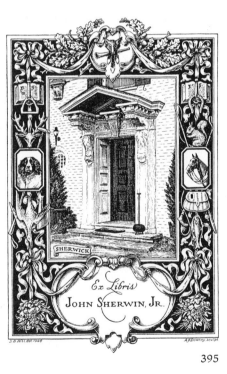

393

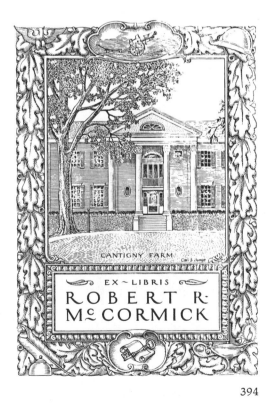

394

395

392: Edwin Greaves. 393: Frederick Garrison Hall. 394: Carl S. Junge. 395: Sara B. Hill.

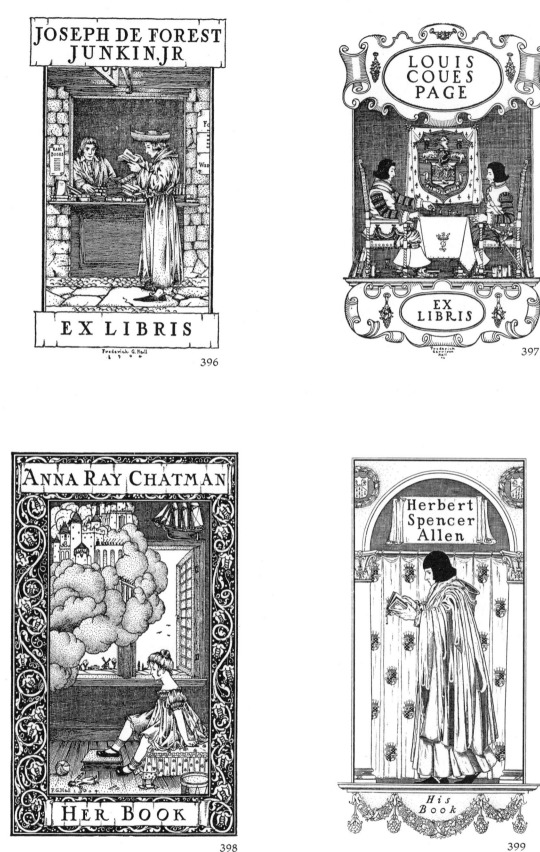

396-399: Frederick Garrison Hall.

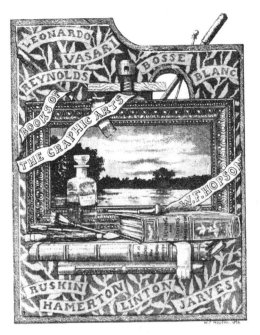

400

401

402

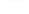

403

400 & 401: William F. Hopson. 402: Anonymous. 403: Jay Chambers.

404-406: James Webb. 407: William Edgar Fisher. 408: James Webb. 409: J. Winfred Spenceley. 410: Edwin Davis French.

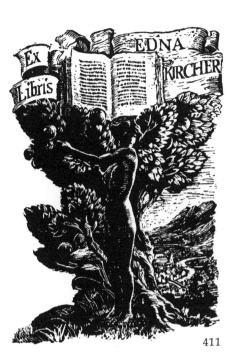

411

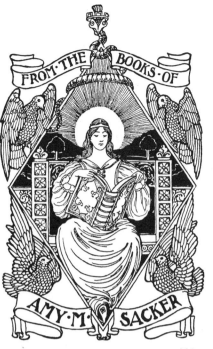

412

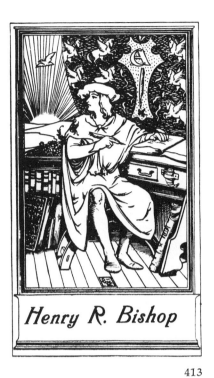

413

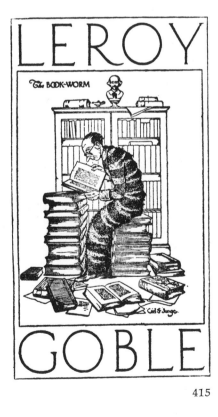

414

415

411: Ralph Fletcher Seymour. 412: Harry E. Goodhue. 413: George Wharton
Edwards. 414 & 415: Carl S. Junge.

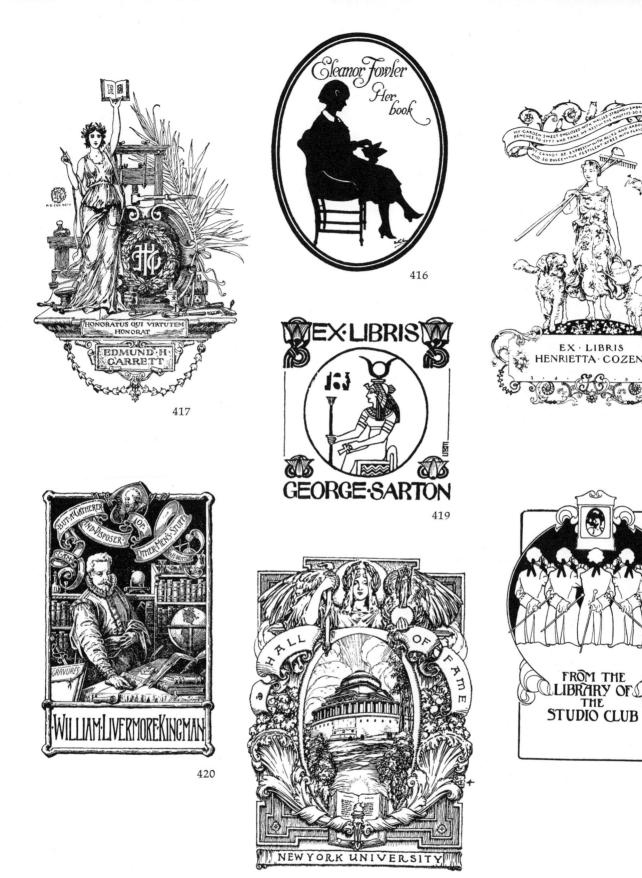

416: Beatrice Sherman. 417: Edmund H. Garrett. 418: Elizabeth Shippen Green. 419: E. M. Sarton. 420: David McNeely Stauffer. 421: George Wharton Edwards. 422: William Edgar Fisher.

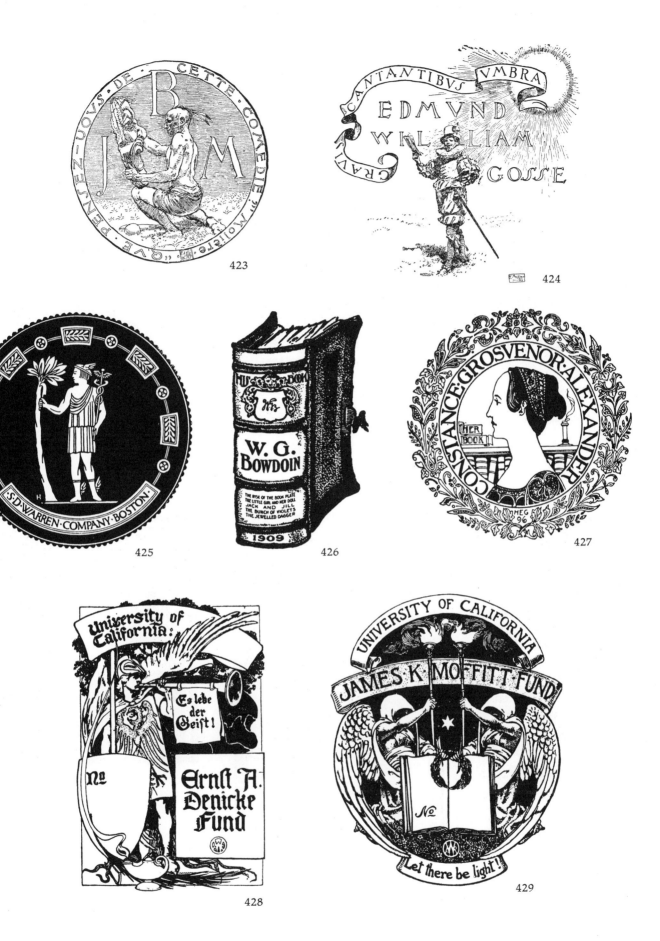

423 & 424: Edwin Austin Abbey (423, for Brander Matthews). 425: Theodore
Brown Hapgood. 426: Anonymous. 427: Harry E. Goodhue. 428 & 429: Albertine
Randall Wheelan.

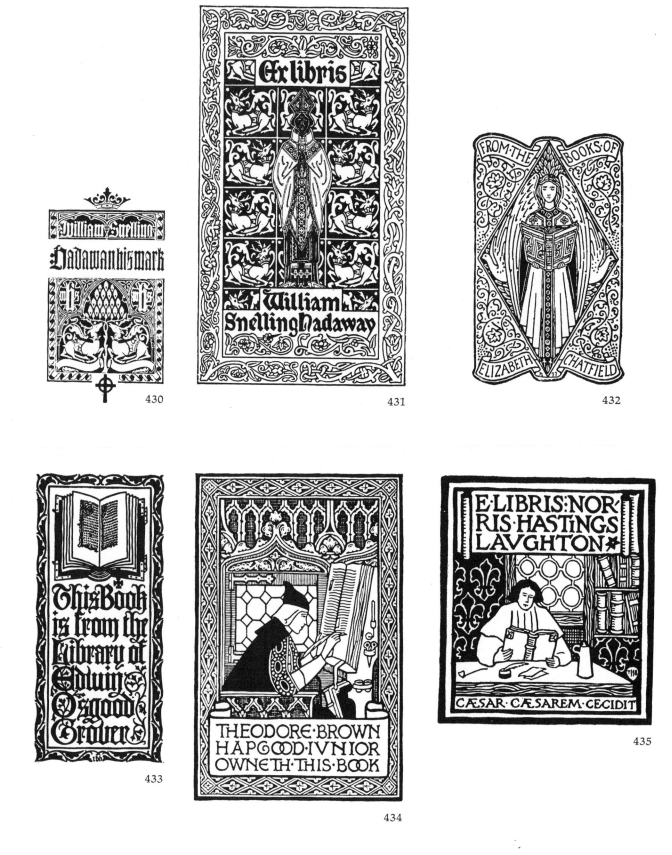

430-432: William Snelling Hadaway. 433-435: Theodore Brown Hapgood.

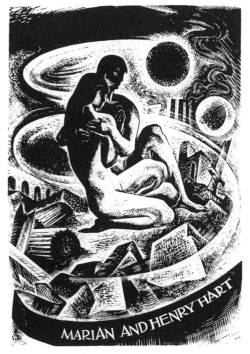

436

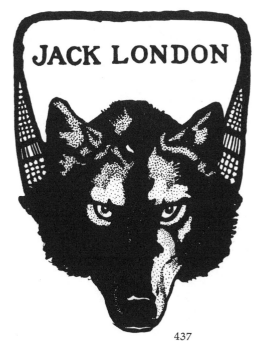

437

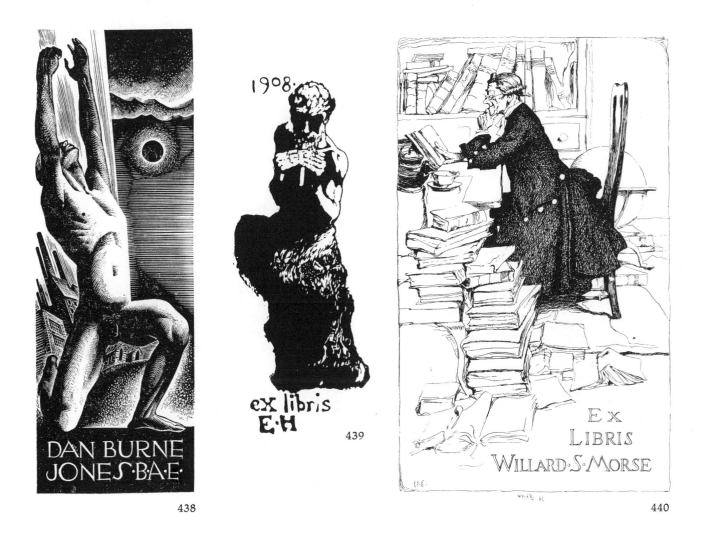

438

439

440

436: Lynd Ward. 437: Ernest James Cross. 438: Lynd Ward. 439: Earl Horter.
440: Howard Pyle.

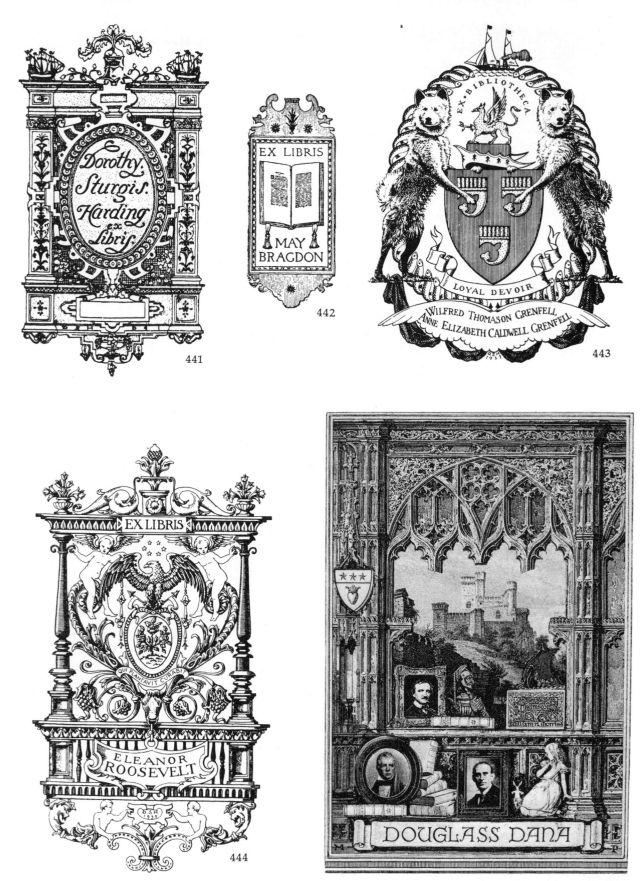

441: Dorothy Sturgis Harding. 442: Claude F. Bragdon. 443 & 444: Dorothy
Sturgis Harding. 445: Matlack Price.

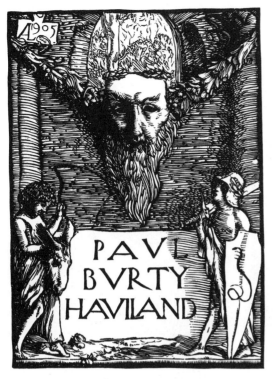

446

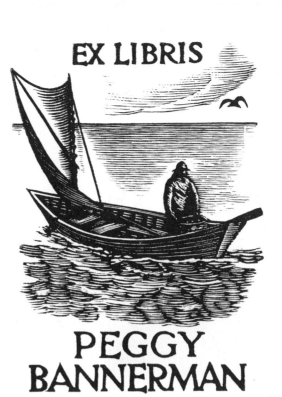

447

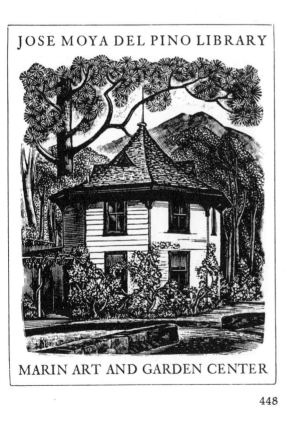

448

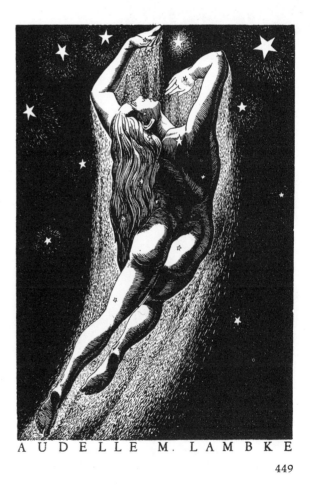

449

446: Allen Lewis. 447: Julius J. Lankes. 448: Malette Dean. 449: Dan Burne Jones.

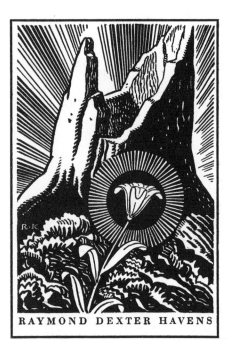

RAYMOND DEXTER HAVENS

450

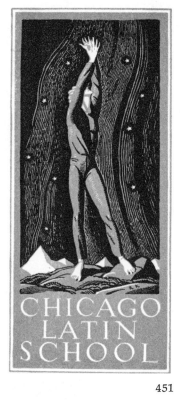

CHICAGO
LATIN
SCHOOL

451

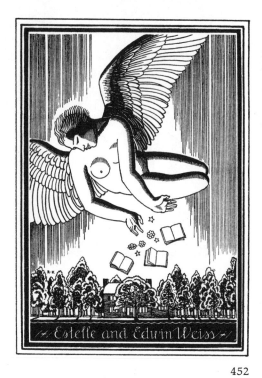

452

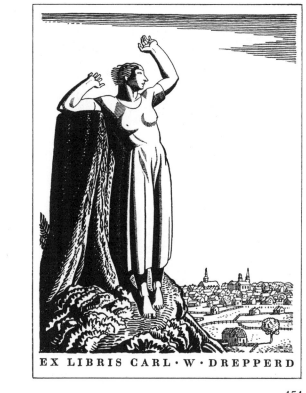

JACQUIE & DAN
BURNE JONES

453

EX LIBRIS CARL·W·DREPPERD

454

450-454: Rockwell Kent.

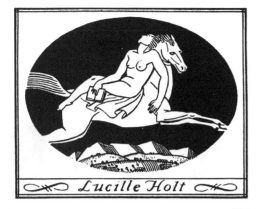

Lucille Holt

455

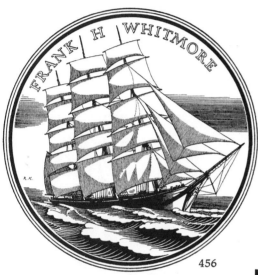

456

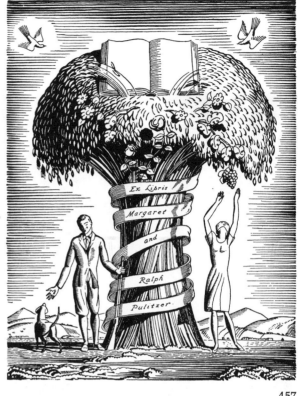

457

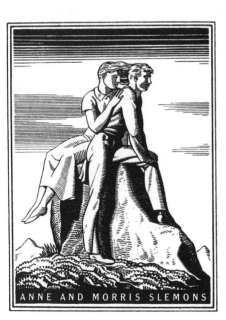

ANNE AND MORRIS SLEMONS

458

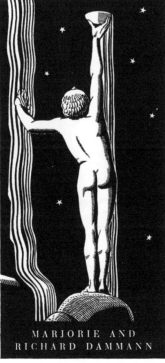

MARJORIE AND
RICHARD DAMMANN

459

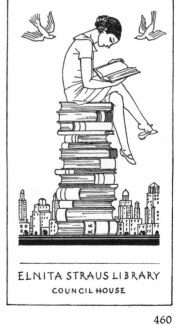

ELNITA STRAUS LIBRARY
COUNCIL HOUSE

460

455-460: Rockwell Kent.

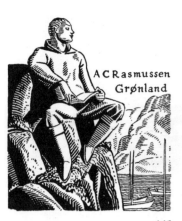

461

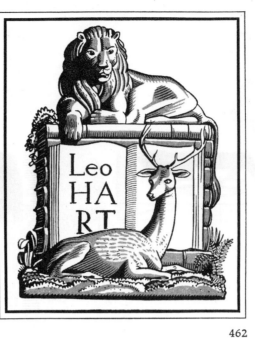

462

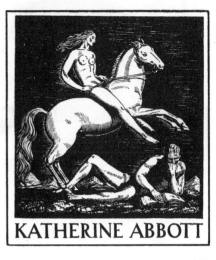

KATHERINE ABBOTT

463

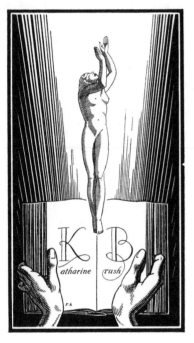

464

FREDERICK BALDWIN ADAMS JR

465

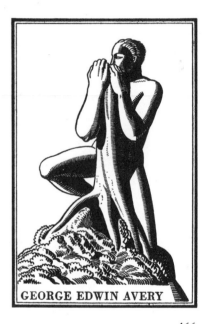

GEORGE EDWIN AVERY

466

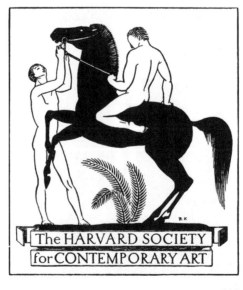

The HARVARD SOCIETY
for CONTEMPORARY ART

468

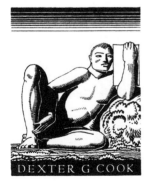

DEXTER G COOK

467

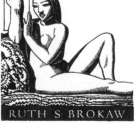

RUTH S BROKAW

469

461-469: Rockwell Kent.

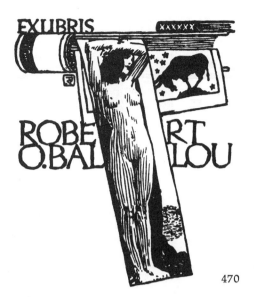

470

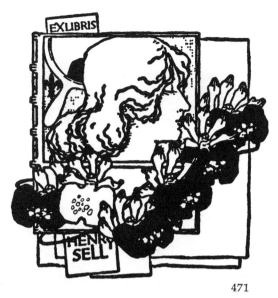

471

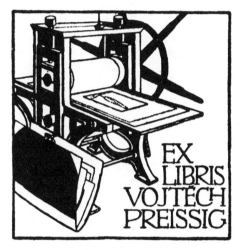

472

473

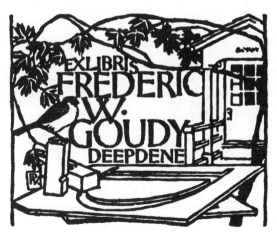

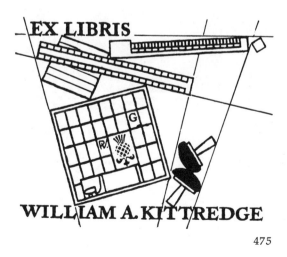

474

475

470-475: Vojtech Preissig.

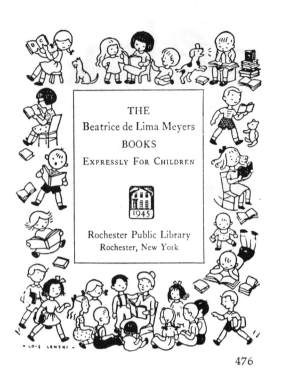

476

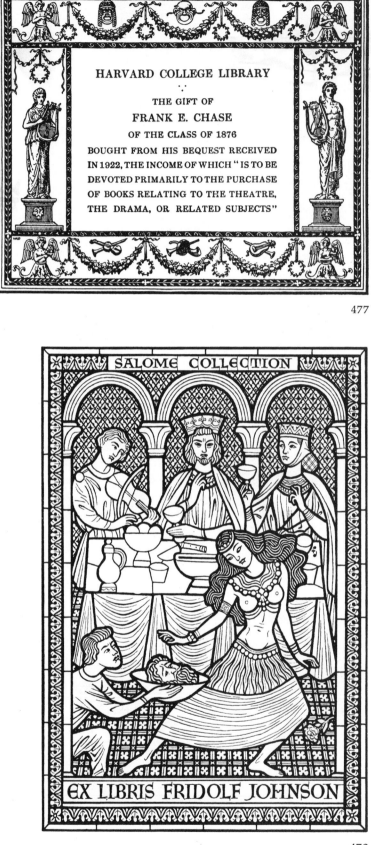

477

478

479

476: Lois Lenski. 477: William Addison Dwiggins. 478 & 479: Fridolf Johnson.

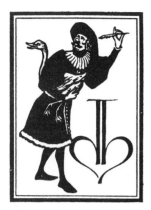

480

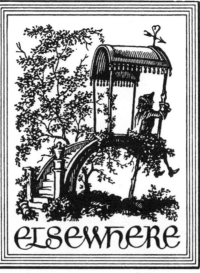

481

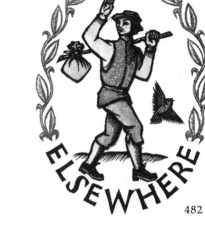

482

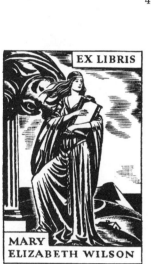

483

484

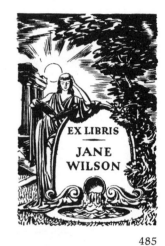

485

486

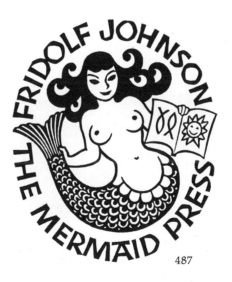

487

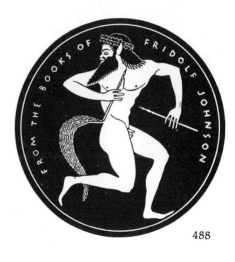

488

480-482: Warren Chappell (480, for Hollis Holland; 481 & 482, for Alfred E. Hamill). 483: Edward A. Wilson. 484: Oscar Berger. 485: Edward A. Wilson. 486: Leonard Baskin. 487 & 488: Fridolf Johnson.

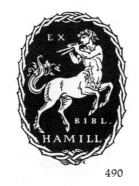

490

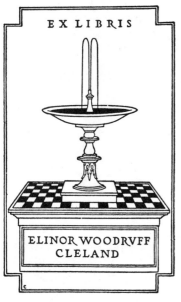

EX LIBRIS

ELINOR WOODRVFF
CLELAND

489

EX LIBRIS
HUBERT EDWARD
ROGERS

491

FRANK H. WATSON

492

EX LIBRIS
ROBERT WOODS BLISS
DUMBARTON OAKS

493

494

EX
LIBRIS

FORT TICONDEROGA

495

FROM THE INCOME OF
A FUND GIVEN BY
HOWARD W. LANG
A PROPRIETOR
BOSTON ATHENÆUM

496

489-492: Thomas Maitland Cleland. 493-496: Rudolph Ruzicka.

497

W·A·KITTREDGE

498

499

500

Anne Lyon Haight

501

EX LIBRIS
Helena M. Hand
PATERSON

502

OSTERHOUT
FREE
LIBRARY

PURCHASED FROM THE
BEQUEST OF
*KATHLEEN
MURPHY
HUNT*

503

· EX LIBRIS ·
Gerald T. Banner

THE ANTHOENSEN PRESS 1972

504

INDEX OF
CHRISTIAN
ART

PRINCETON
UNIVERSITY

505

497–502: Bruce Rogers. 503: P. J. Conkwright. 504: Fred Anthoensen. 505: P. J. Conkwright.

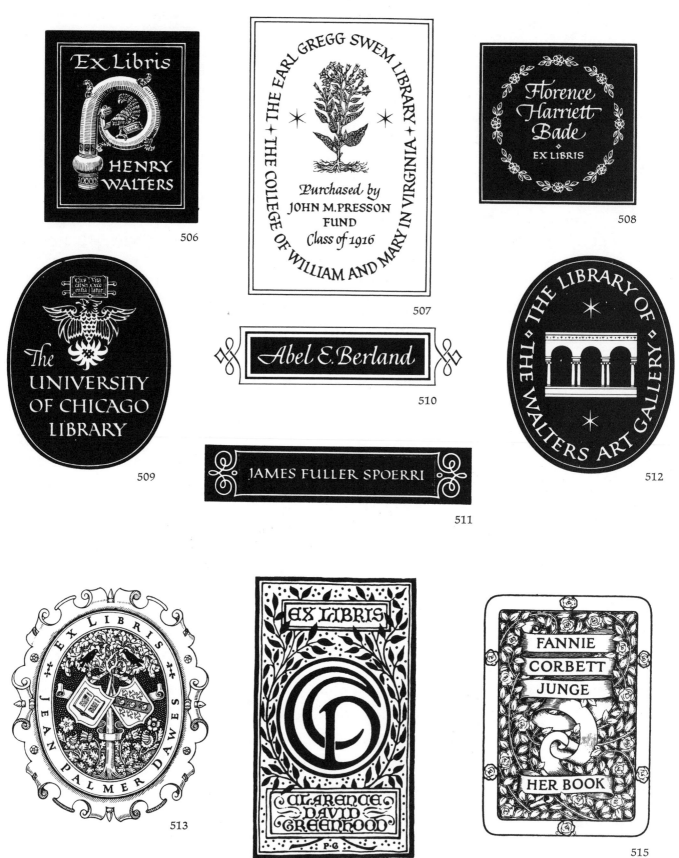

506-512: James Hayes. 513: Rodney Chirpe. 514: Porter Garnett. 515: Carl S. Junge.

516

517

518

519

EX LIBRIS JACK & TEDDIE WOLFF

520

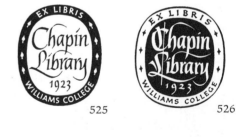

521

522

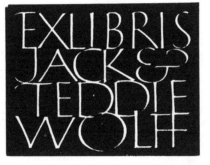

525

526

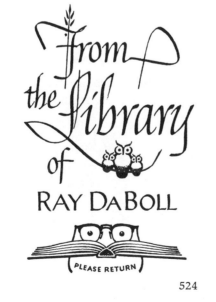

523

From the Library of RAY DaBoll

PLEASE RETURN

524

SIMON DE VAULCHIER

527

516 & 517: Rick Cusick. 518: Boris Artzebasheff. 519: Fritz Kredel. 520: Lili Cassel. 521: Ernst A. Spueler. 522: Rick Cusick (owner unknown). 523: Byron Macdonald. 524: Raymond DaBoll. 525 & 526: Fridolf Johnson. 527: Daniel Berkeley Updike.

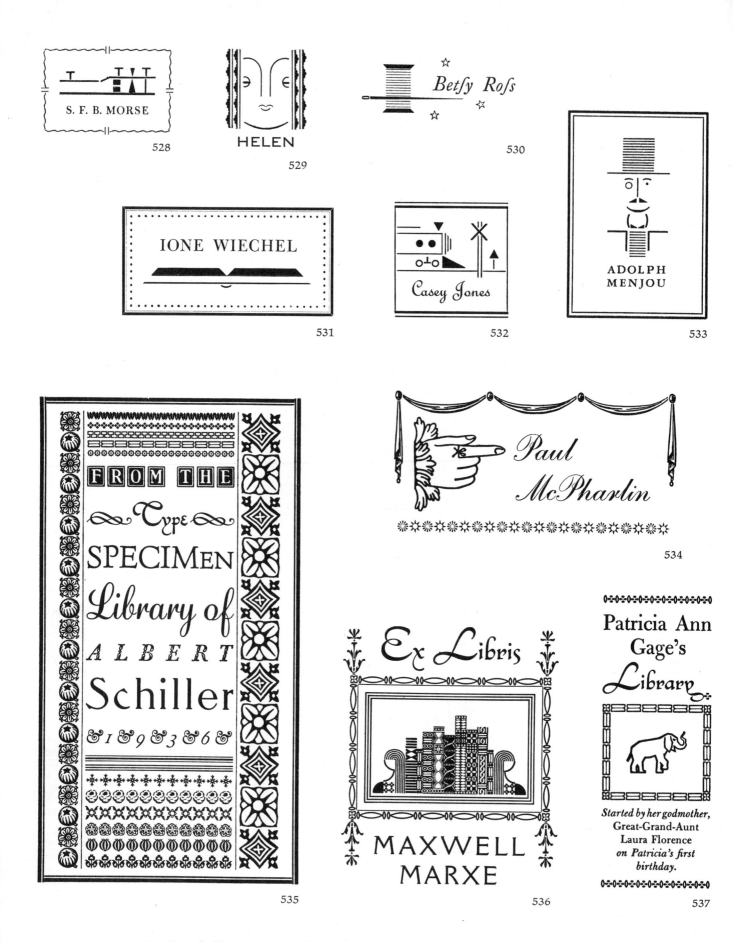

S. F. B. MORSE

528

HELEN

529

Betſy Roſs

530

IONE WIECHEL

531

Casey Jones

532

ADOLPH
MENJOU

533

FROM THE *Type* SPECIMEN *Library of* A L B E R T Schiller ❧ 1 9 3 6 ❧

535

Paul McPharlin

534

Ex Libris

MAXWELL
MARXE

536

Patricia Ann
Gage's *Library*

Started by her godmother,
Great-Grand-Aunt
Laura Florence
on Patricia's first
birthday.

537

528-533: G. Harvey Petty (all but 531 done as a joke); 534: Paul McPharlin.
535-537: Albert Schiller.

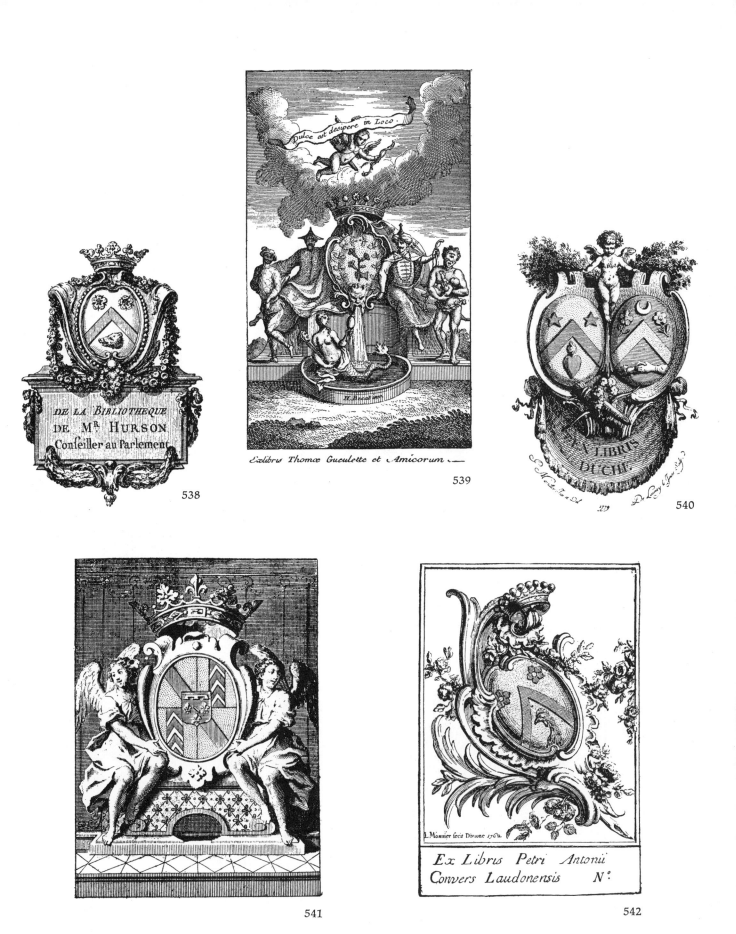

538

De la Bibliotheque de Mr Hurson Conseiller au Parlement.

539

Exlibris Thomæ Gueulette et Amicorum.

540

541

542

Ex Libris Petri Antonii Convers Laudonensis N°

538: Anonymous. 539: H. Becat (for Thomas Gueulette). 540: Anonymous (for the Duché family). 541: Anonymous (for the abbot of Bourbon-Rothelin). 542: Anonymous (for Pierre Antoine Convers).

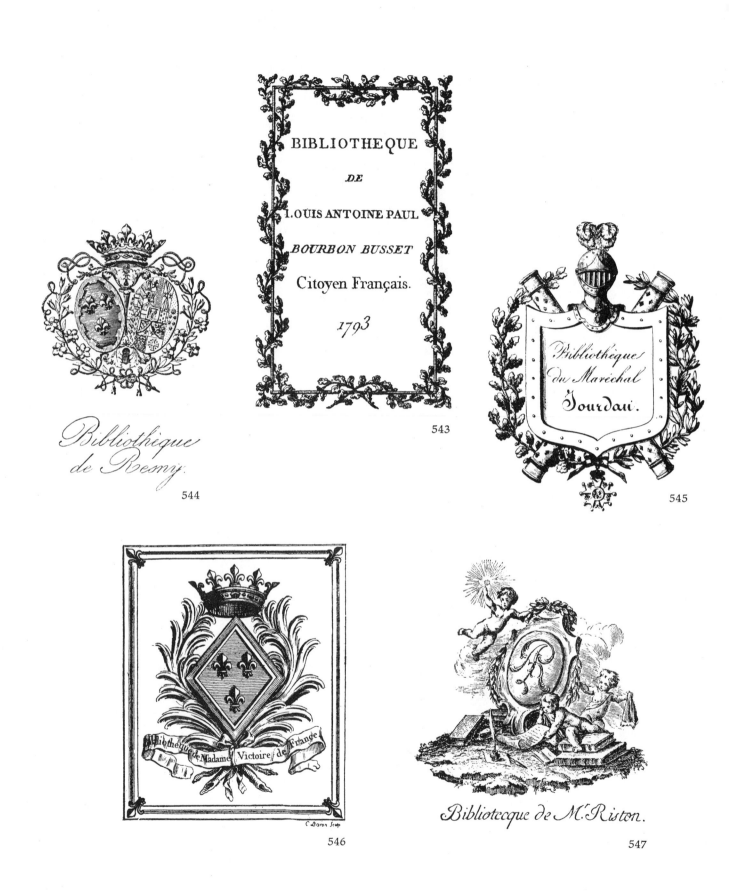

BIBLIOTHEQUE

DE

LOUIS ANTOINE PAUL

BOURBON BUSSET

Citoyen Français.

1793

543

Bibliothèque de Remy.

544

Bibliothèque du Maréchal Jourdan.

545

Bibliothèque de Madame Victoire de France

C. Baron Sculp.

546

Bibliotecque de Mr. Riston.

547

543: Anonymous. 544: Anonymous (for the Duchesse de Berry). 545-547: Anonymous.

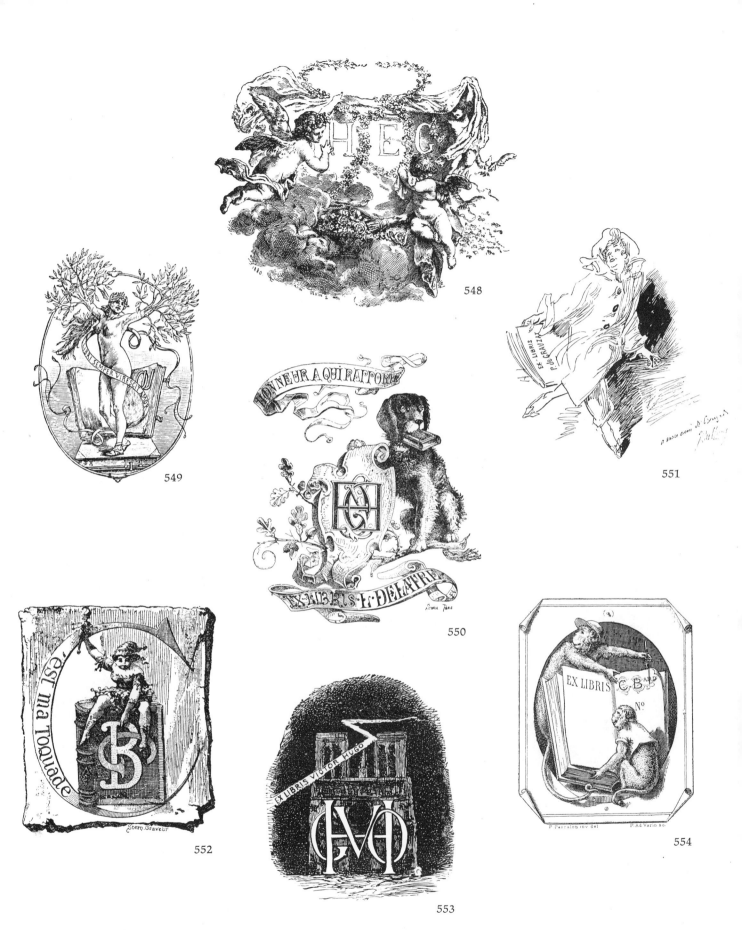

548: Anonymous (for Henri Greslie). 549: Félicien Rops (for *Le Livre Moderne*). 550: Stern. 551: Jules Chéret. 552: Stern. 553: Aglaüs Bouvenne. 554: P. Pascalon (for C. Bayard).

556

555

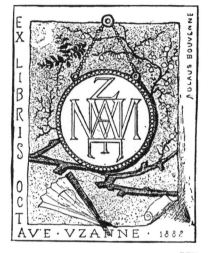

557

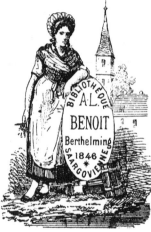

558

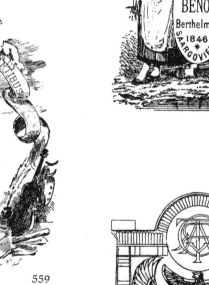

559

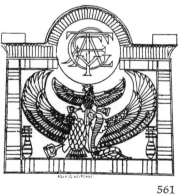

561

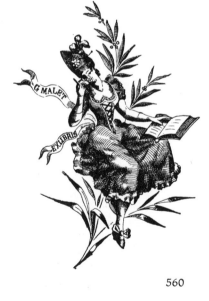

560

555: Anonymous. 556: Stern. 557: Aglaüs Bouvenne. 558: Arthur Benoit. 559 &
560: Anonymous. 561: Aglaüs Bouvenne (for Théophile Gautier).

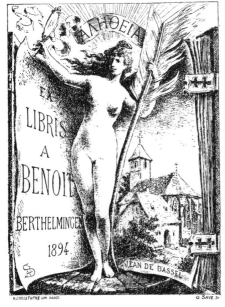

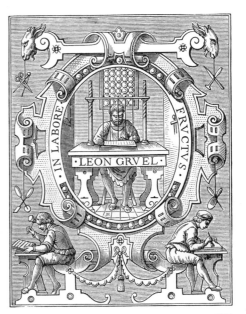

562

563

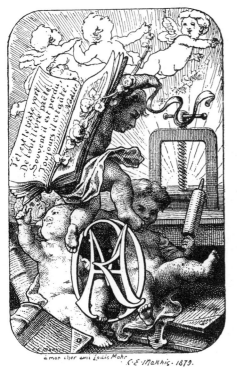

564

565

562 & 563: Anonymous. 564: C. E. Matthis (for Louis Mohr). 565: Albert Robida
(owner unknown).

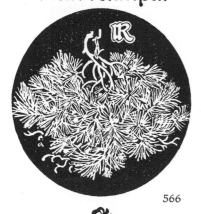

EX LIBRIS
Ivan Rampal

566

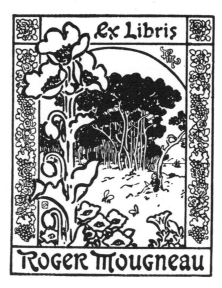

567

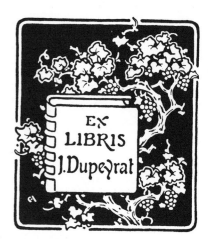

568

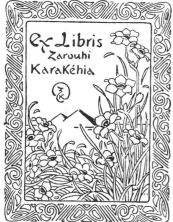

569

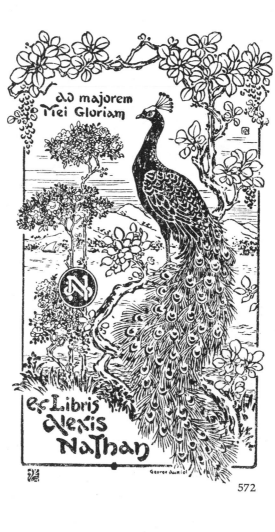

ad majorem
Mei Gloriam

ex Libris
Alexis
Nathan

572

570

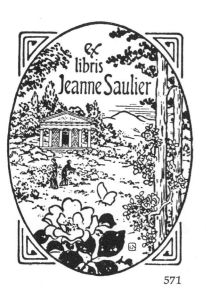

571

573

566-573: Georges Auriol.

574

575

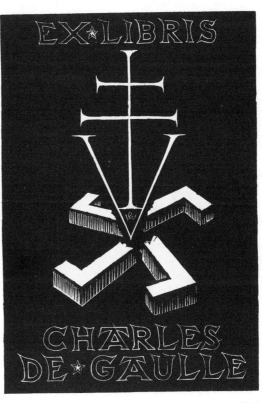

576

577

574: H. Carlier. 575: Georges Auriol. 576: Henry André (for A. Geoffroy). 577: Ernst Huber.

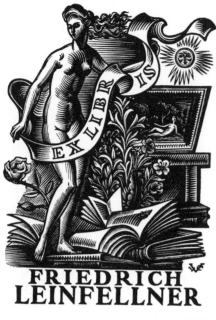

FRIEDRICH
LEINFELLNER

578

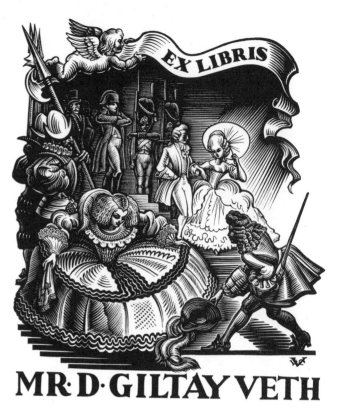

MR·D·GILTAY VETH

579

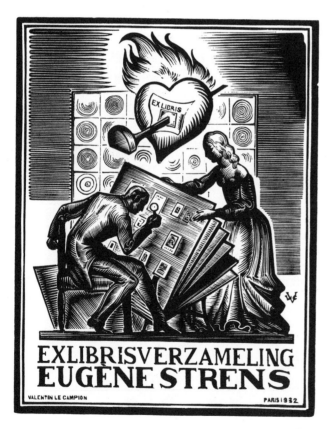

EXLIBRISVERZAMELING
EUGENE STRENS

VALENTIN LE CAMPION

PARIS 1932

580

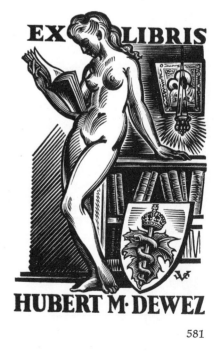

HUBERT M·DEWEZ

581

578-581: Valentin Le Campion.

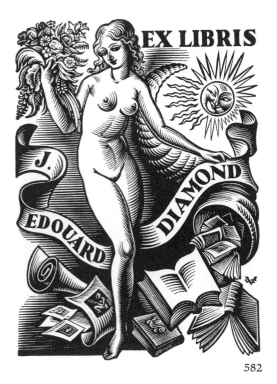

582

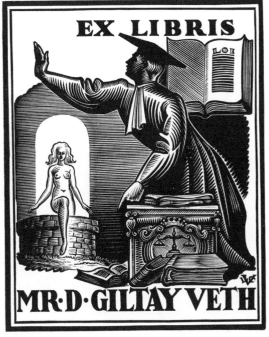

583

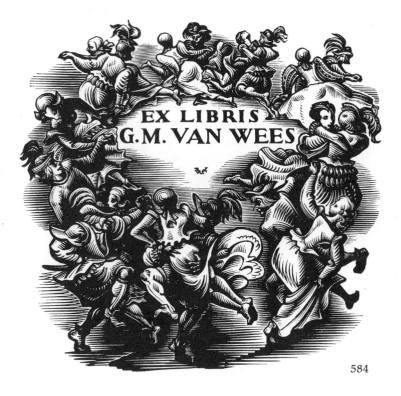

584

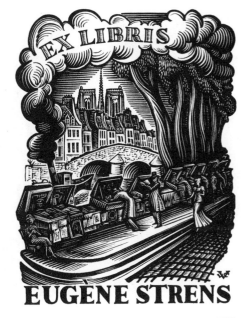

585

582-585: Valentin Le Campion.

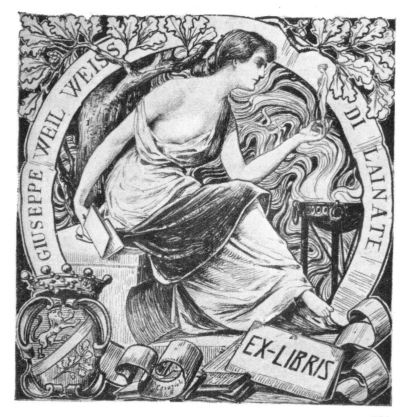

586

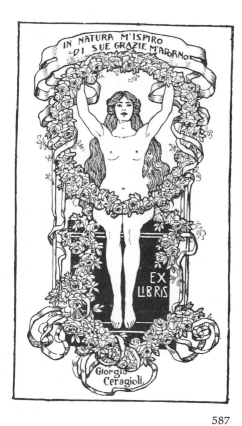

587

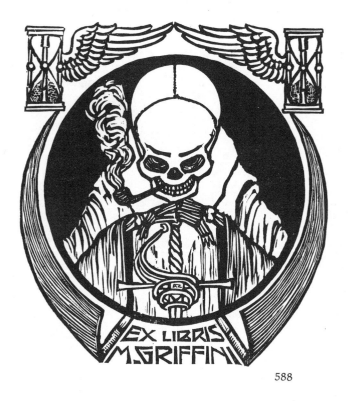

588

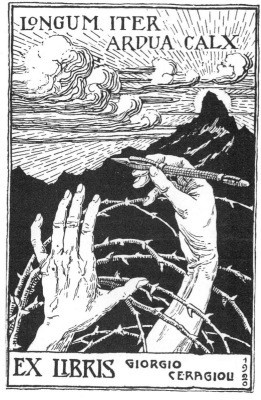

589

586 & 587: Giorgio Ceragioli. 588: Alberto Zanverdiani. 589: Giorgio Ceragioli.

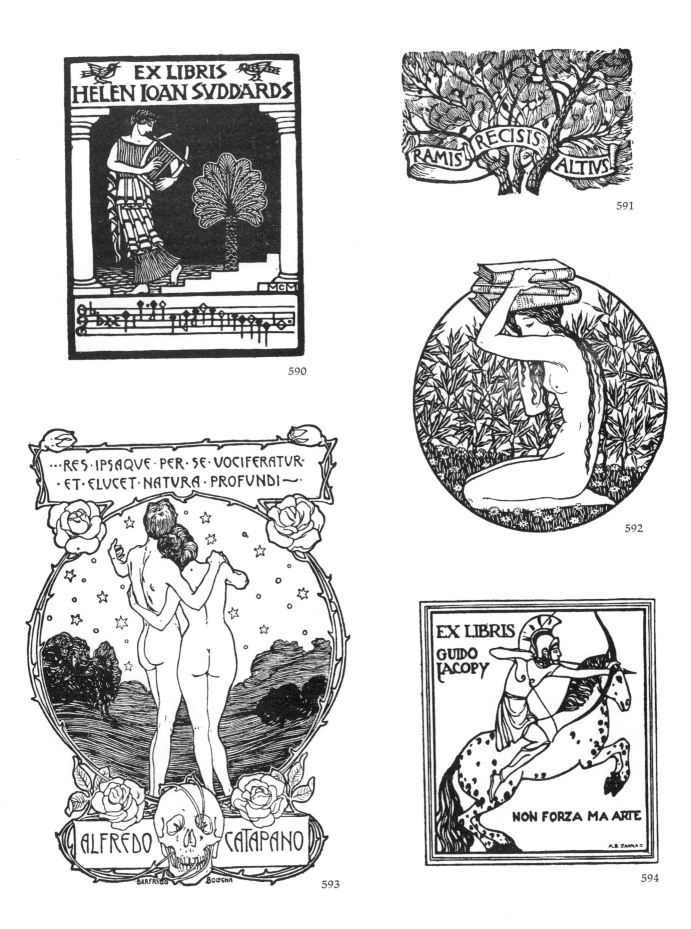

590: Maria Cecelia Monteverde. 591: Adolfo de Carolis (owner unknown). 592: Leonella Nasi (owner unknown). 593: Alfredo Baruffi. 594: Anna Beatrice D'Anna.

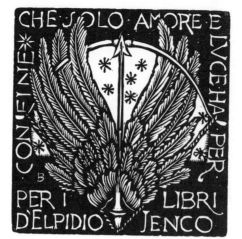

595

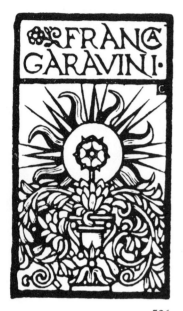

596

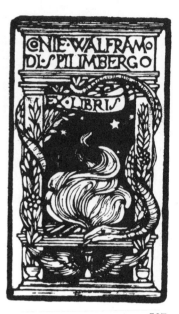

597

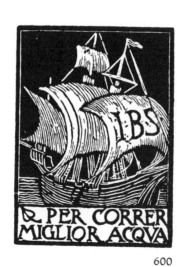

598

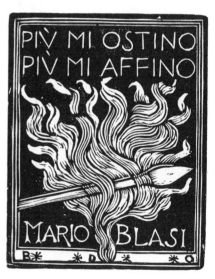

601

599

600

595: Bruno da Osimo. 596 & 597: Giulio Cisari. 598: Antonello Moroni (owner unknown). 599: Bruno da Osimo. 600: Adolfo de Carolis (owner unknown). 601: Bruno da Osimo.

602

603

604

605

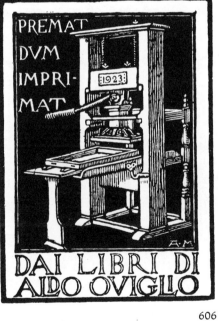

606

602: Adolfo de Carolis (owner unknown). 603: Benvenuto Disertori. 604: Adolfo de Carolis. 605 & 606: Antonello Moroni.

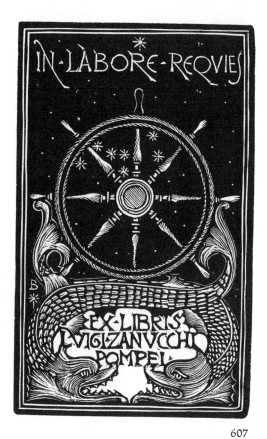

607

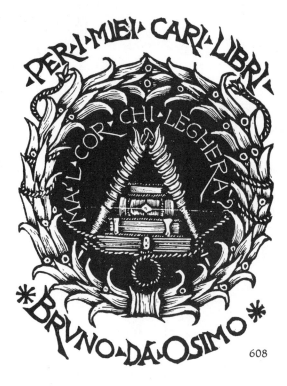

608

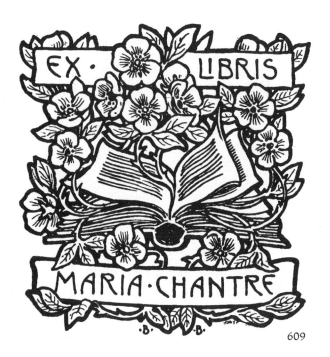

609

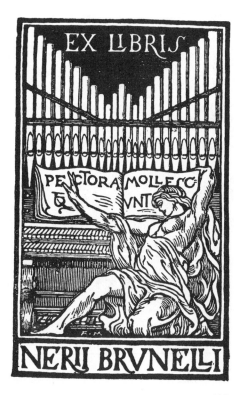

610

607 & 608: Bruno da Osimo. 609: Alfredo Baruffi. 610: Antonello Moroni.

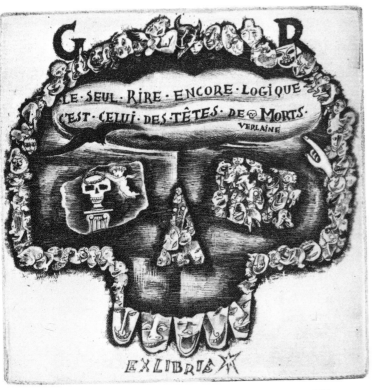

611

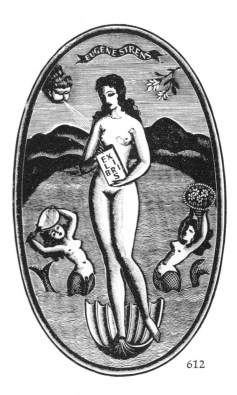

612

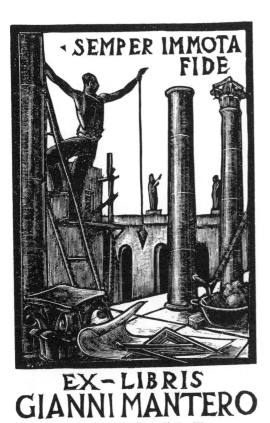

613

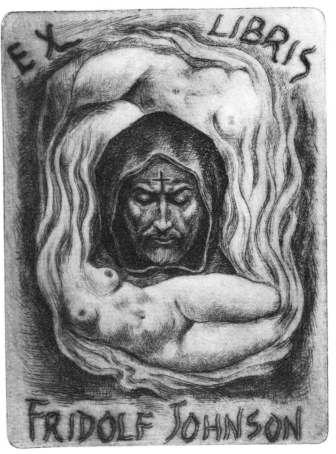

614

611: Michel Fingesten (owner unknown). 612: Italo Zetti. 613: Anonymous. 614: Enrico Vannuccini.

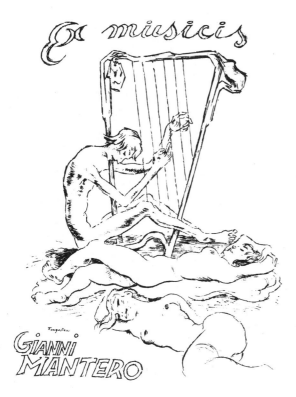

615

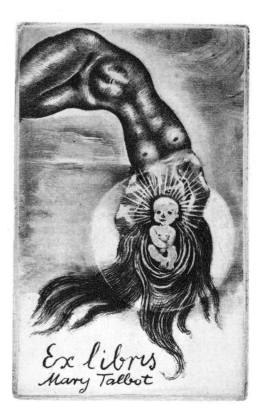

616

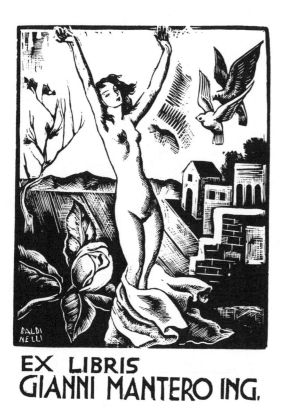

617

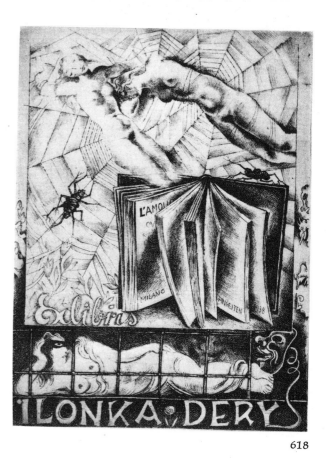

618

615 & 616. Michel Fingesten. 617: Armando Baldinelli. 618: Michel Fingesten.

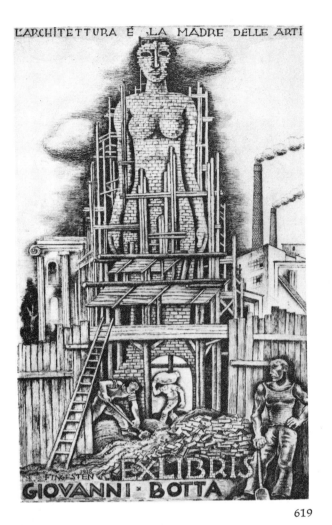

619

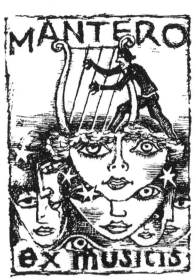

620

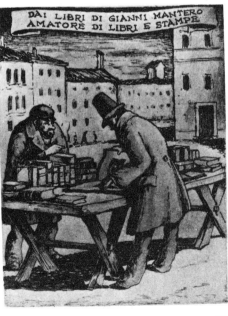

621

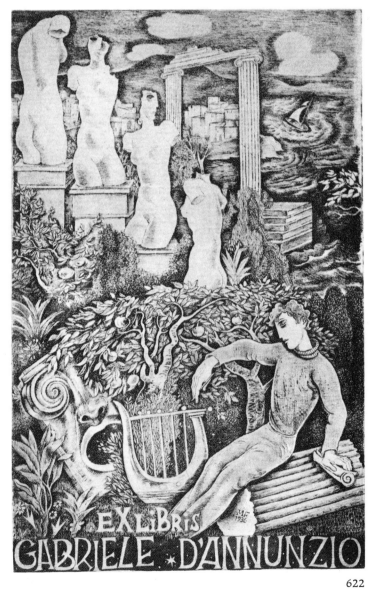

622

619 & 620: Michel Fingesten. 621: F. Brunello. 622: Michel Fingesten.

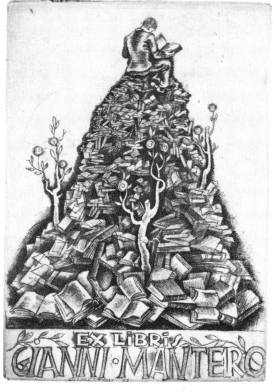

623

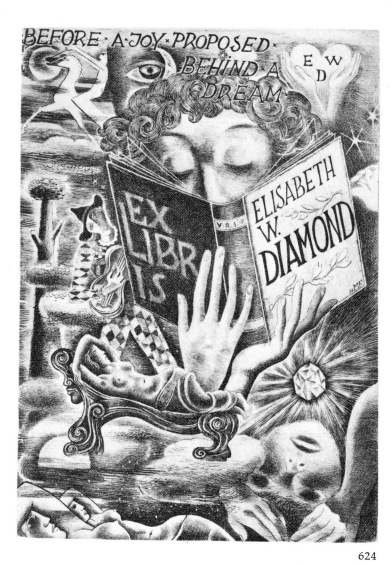

624

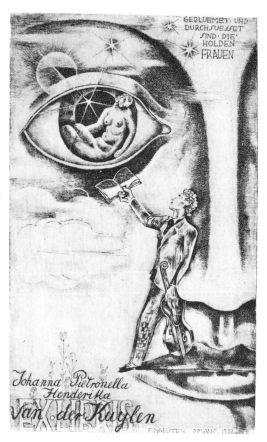

625

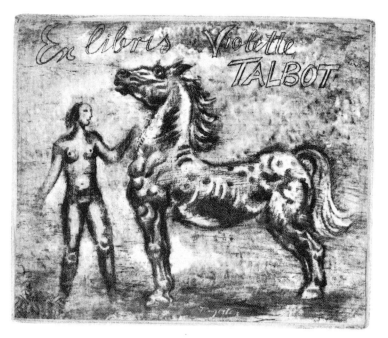

626

623-626: Michel Fingesten.

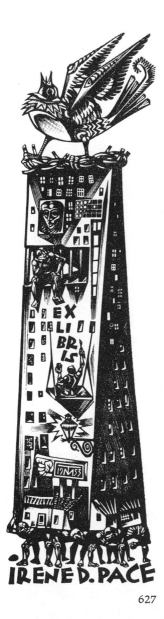

EX LI BR IS

IRENE D. PACE

627

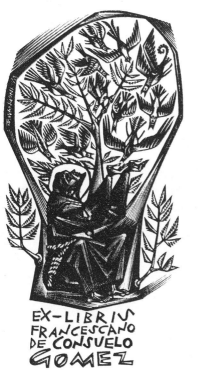

EX-LIBRIS
FRANCESCANO
DE CONSUELO
GOMEZ

628

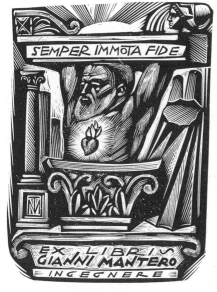

SEMPER IMMOTA FIDE

EX LIBRIS
GIANNI MANTERO
INGEGNERE

629

EXLIBRIS

OLIVIERO
BELLINI
CHIRURGO

630

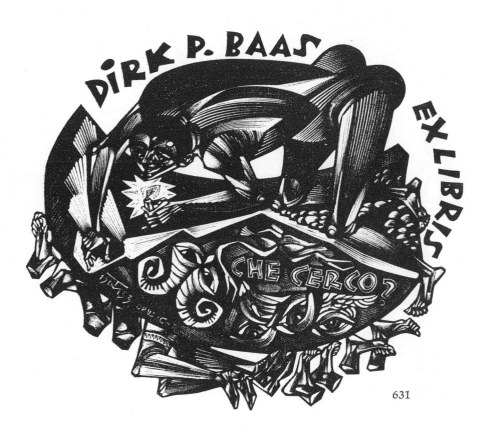

DIRK P. BAAS

EX LIBRIS

CHE CERCO?

631

627-631: Tranquillo Marangoni.

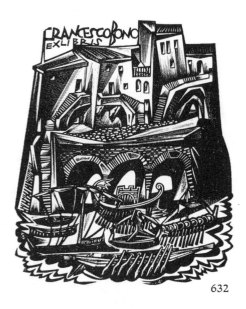

632

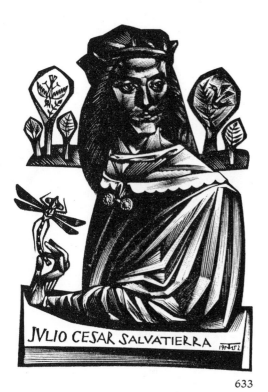

633

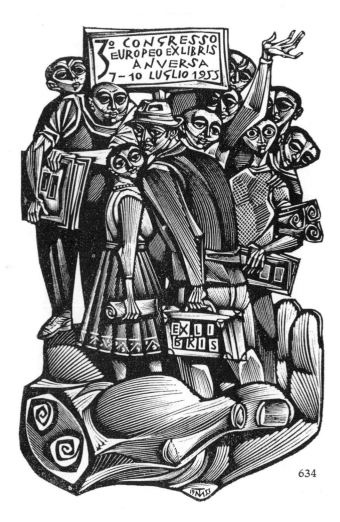

634

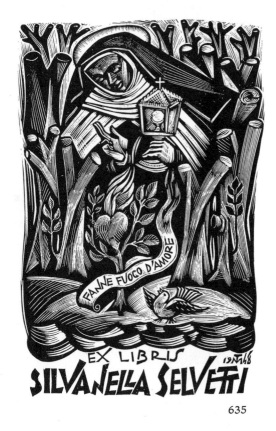

635

632-635: Tranquillo Marangoni.

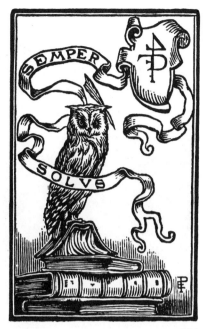

636

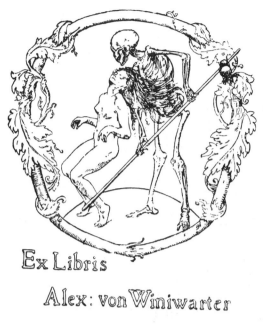

Ex Libris

Alex: von Winiwarter

637

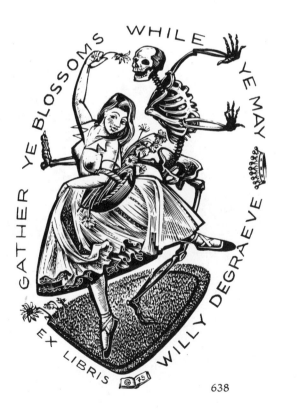

638

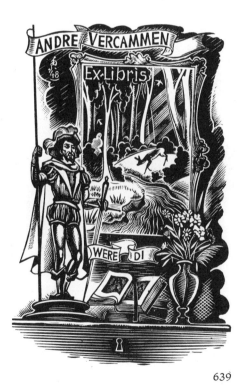

639

636: Edward Pellens (for Fernand Donnet). 637: A. Rassenfosse. 638: Gerard
Gaudaen. 639: Luc de Jaegher.

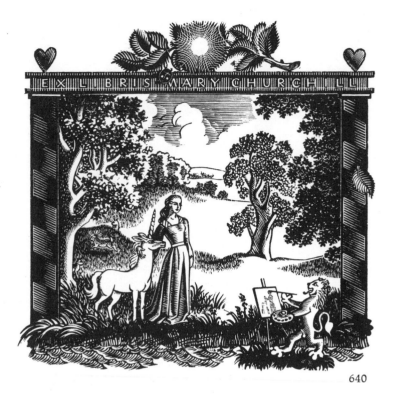

640

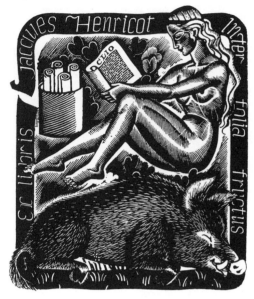

641

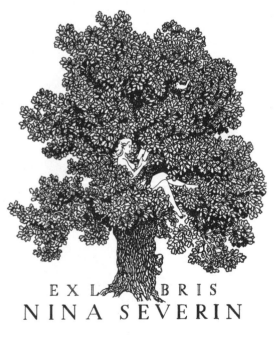

EX L BRIS
NINA SEVERIN

642

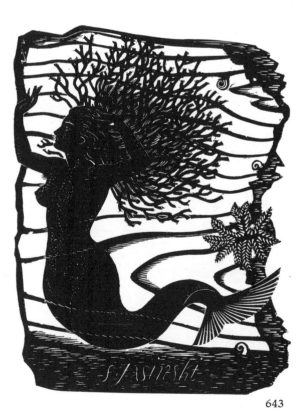

643

640-643: Mark Severin.

644

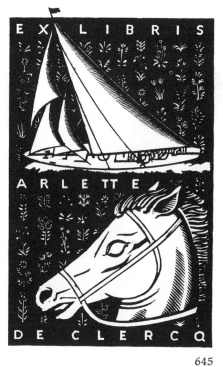

645

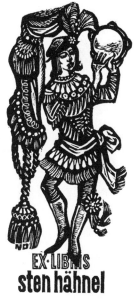

646

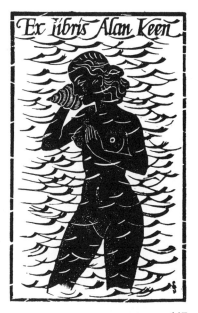

647

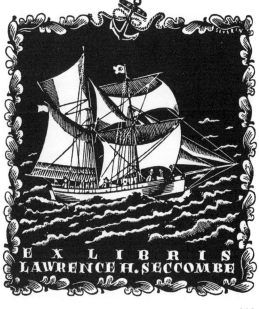

648

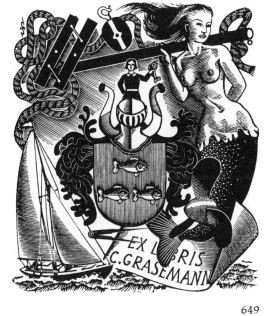

649

644: Piet Janssens. 645: Mark Severin. 646: Nelly Degouy. 647-649: Mark Severin.

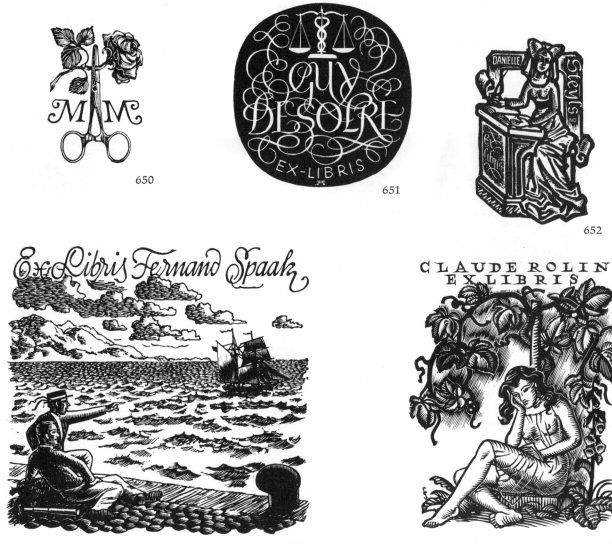

650

651

652

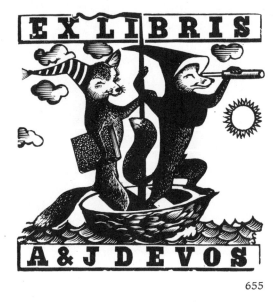

653

654

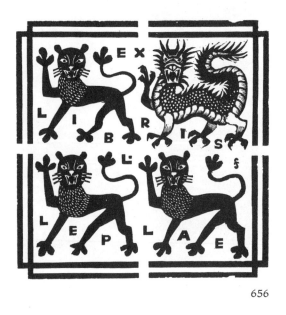

655

656

650: Piet van Roemburg (owner unknown). 651: Désiré Acket. 652: Nelly Degouy. 653-656: Mark Severin.

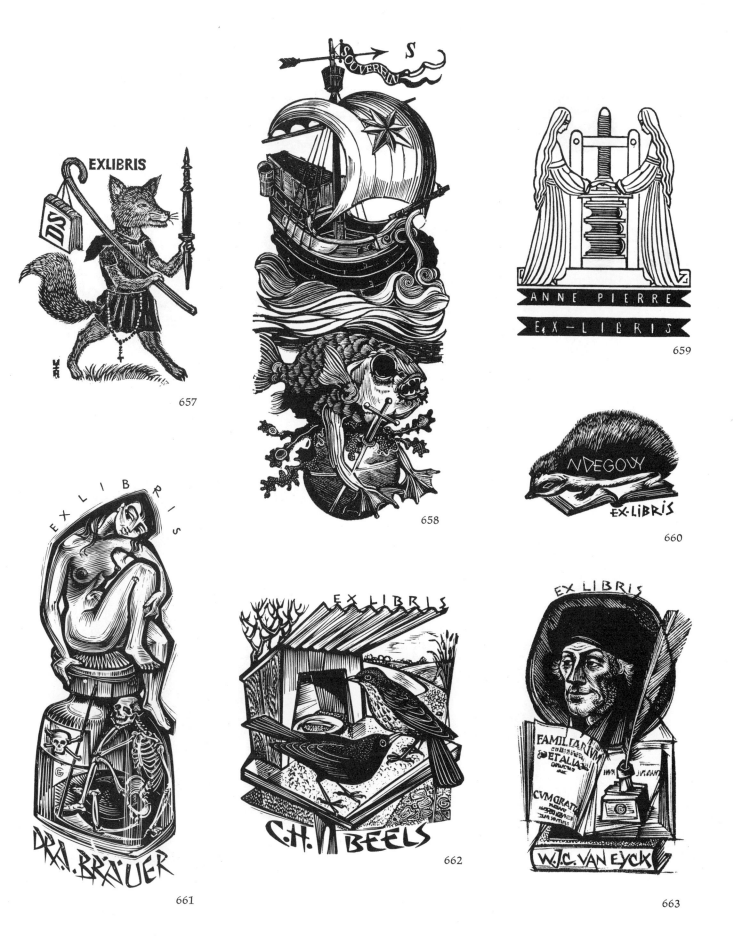

657: Anton Vermeylen (owner unknown). 658: Piet van Roemburg. 659: Victor Stuyvaert. 660: Nelly Degouy. 661-663: Gerard Gaudaen.

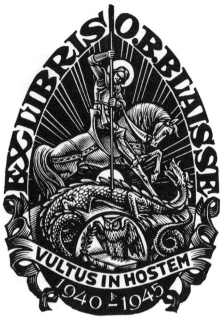

664

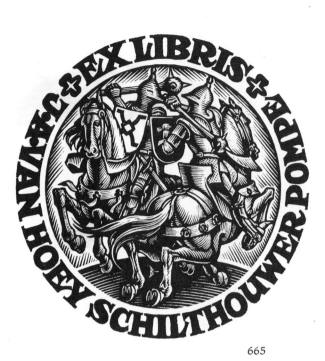

665

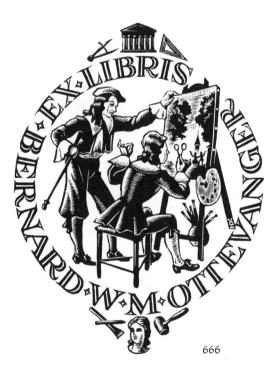

666

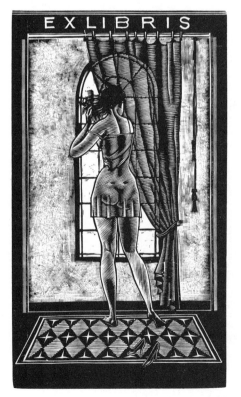

667

664 & 665: Nico Bulder. 666: H. D. Voss. 667: Wim Zweirs (owner unknown).

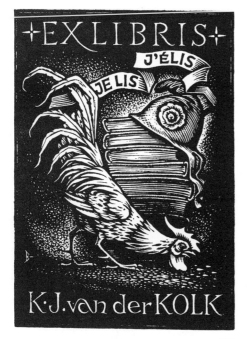

668

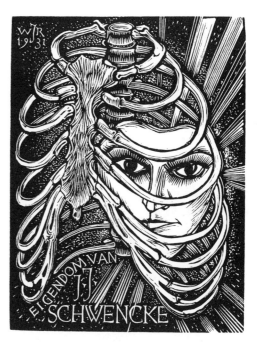

669

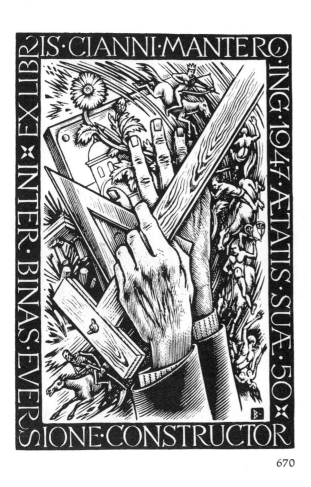

670

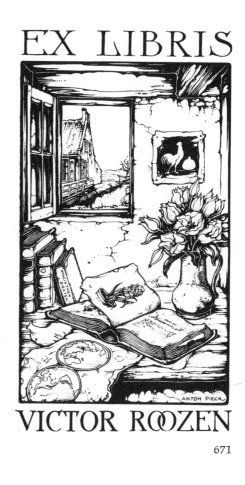

671

668: Nico Bulder. 669: W. J. Rozendaal. 670: Nico Bulder. 671: Anton Pieck.

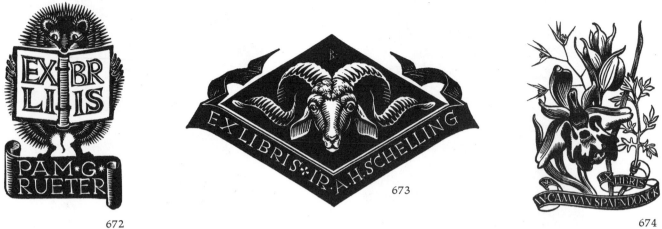

672

673

674

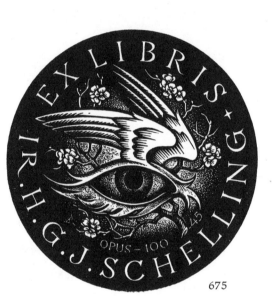

675

676

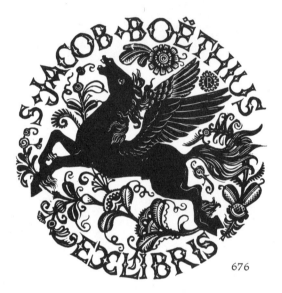

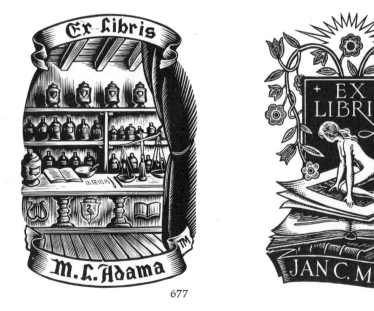

677

678

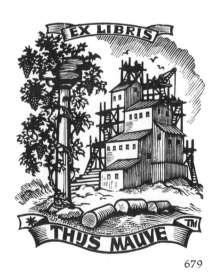

679

672: Pam G. Rueter. 673: Nico Bulder. 674: Dirk van Gelder. 675: Nico Bulder.
676: Pam G. Rueter. 677: Thijs Mauve. 678: Jan C. Maas. 679: Thijs Mauve.

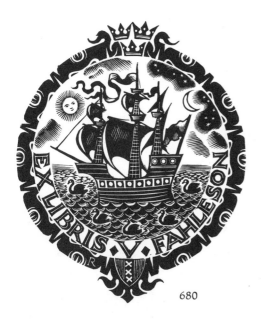

680

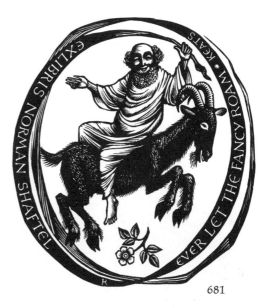

681

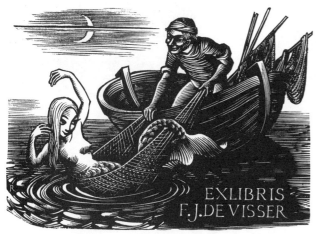

682

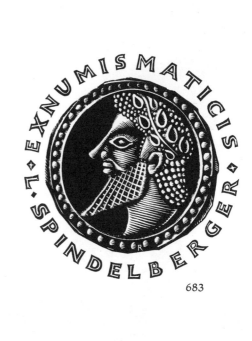

683

684

685

680-685: Pam G. Rueter.

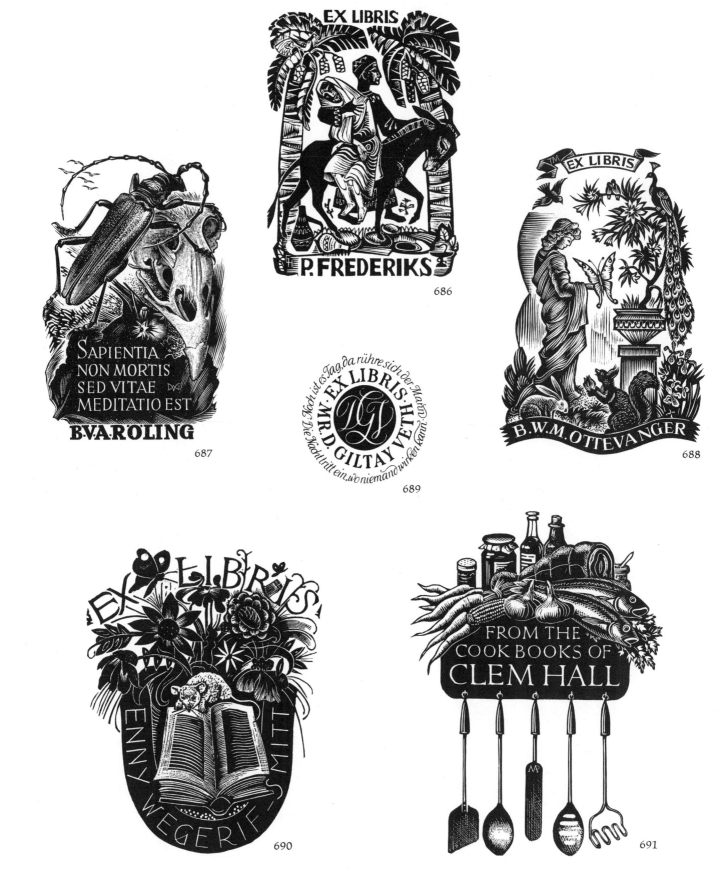

Ex Libris

P. FREDERIKS

686

SAPIENTIA
NON MORTIS
SED VITAE
MEDITATIO EST

B.V.A. ROLING

687

Ex Libris
M.R.D. GILTAY VETH

689

Ex Libris

B.W.M. OTTEVANGER

688

Ex Libris

ENNY WEGERIF SMITT

690

FROM THE
COOK BOOKS OF
CLEM HALL

691

686: Elly van den Hoeven. 687: Dirk van Gelder. 688: Thijs Mauve. 689: Alice
Horodisch-Garman. 690: Wassenaar. 691: Mia Van Regteren Altena.

692

693

694

695

696

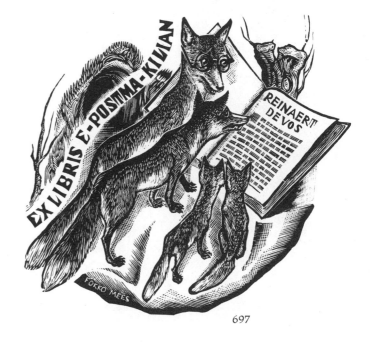

697

692: Akke Sins. 693 & 694: Dirk van Gelder. 695: Alice Horodisch-Garman.
696: Nico Bulder. 697: Fokko Mees.

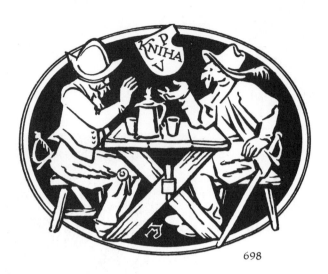

698

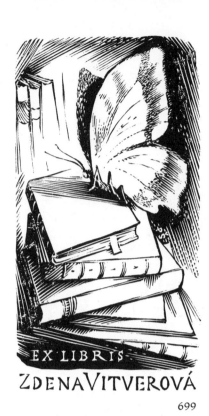

EX LIBRIS
ZDENA VITVEROVÁ

699

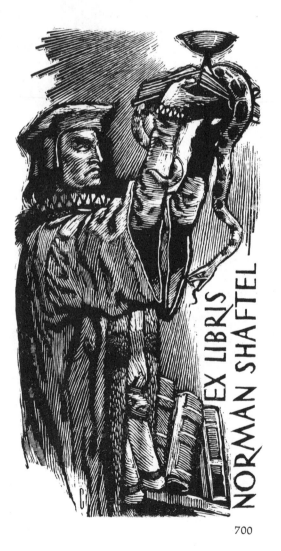

EX LIBRIS
NORMAN SHAFTEL

700

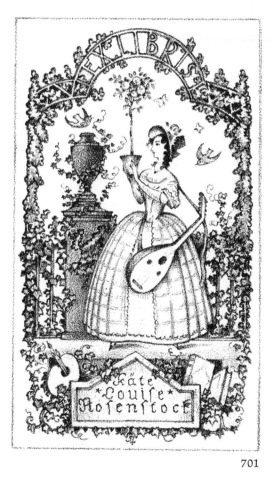

701

698: Jaroslav Marik. 699: Pavel Simon. 700: Vojtech Cinybulk. 701: Hugo Steiner-Prag.

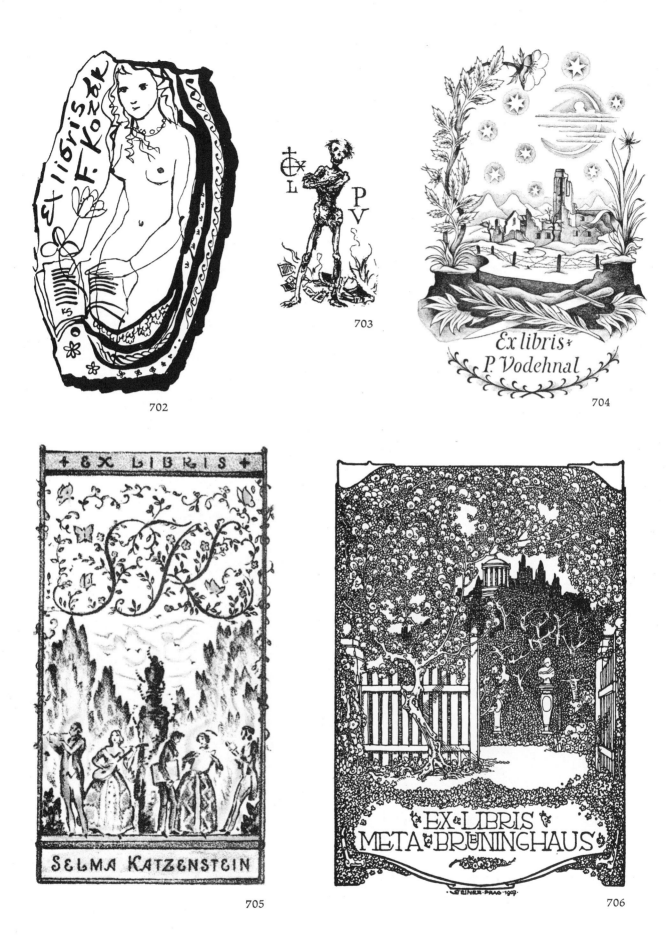

702: Karel Svolinsky. 703: Jaroslav Vodrazka (owner unknown). 704: Karel Kinsky. 705 & 706: Hugo Steiner-Prag.

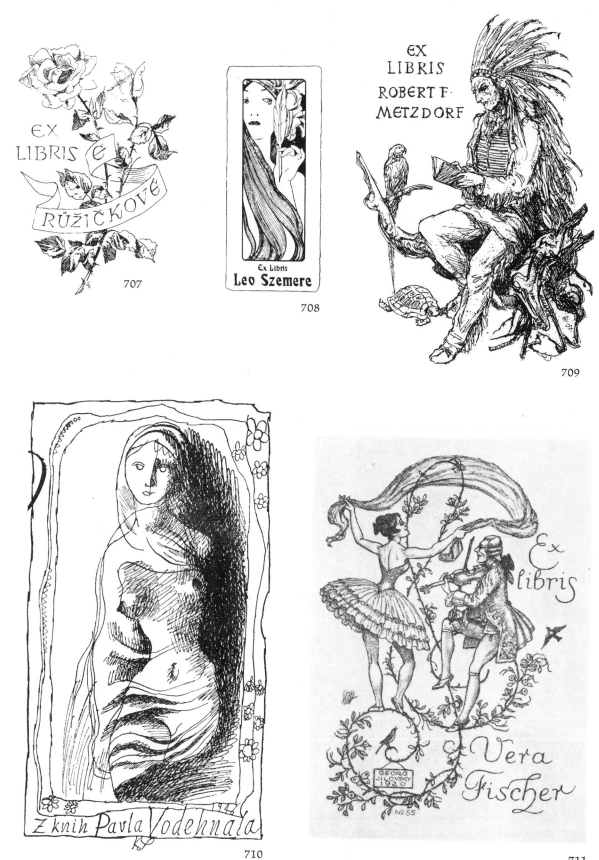

707: Jaroslav Vodrazka. 708: Alfons Mucha. 709: Jaroslav Vodrazka. 710: Karel
Svolinsky. 711: Georg Jilovsky.

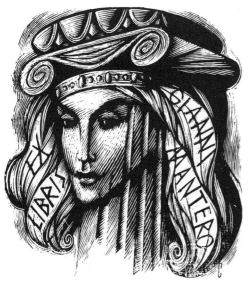

712

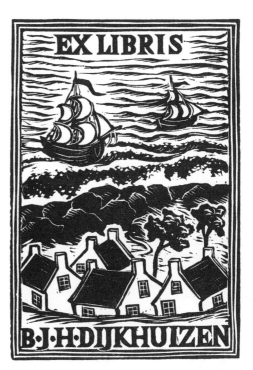

713

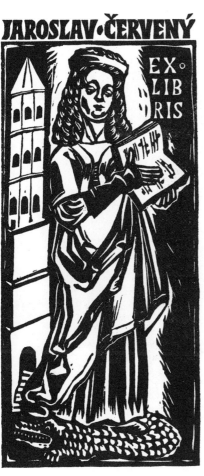

714

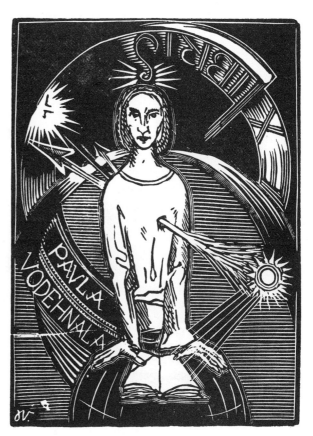

715

712: Vojtech Cinybulk. 713 & 714: Michael Florian. 715: Josef Vacal.

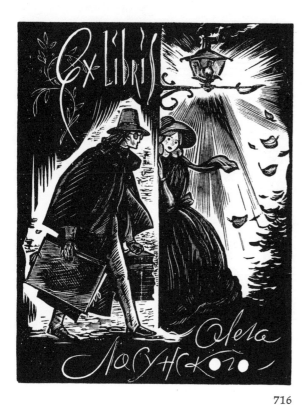

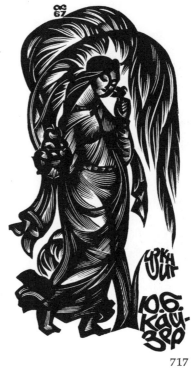

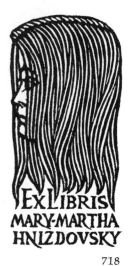

716

717

718

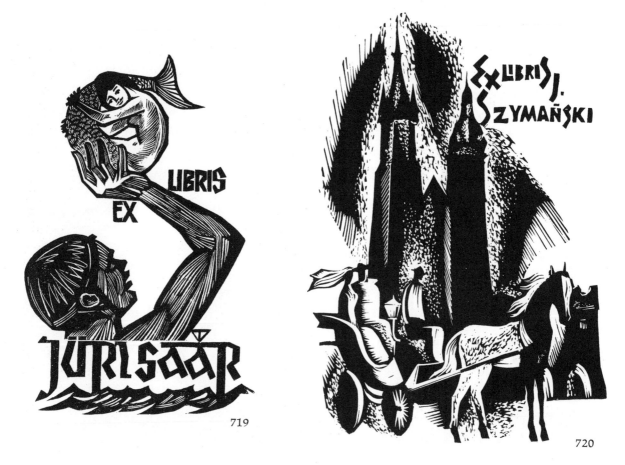

719

720

716: Evgenii N. Goliakovski (for Oleg Losunskii). 717: Anatolii Kalashnikov (for Y. B. Kaizer). 718: Jacques Hnizdovsky. 719: Vaino Tonisson. 720: G. I. Ratner.

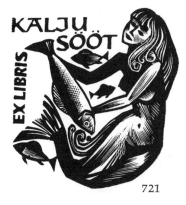

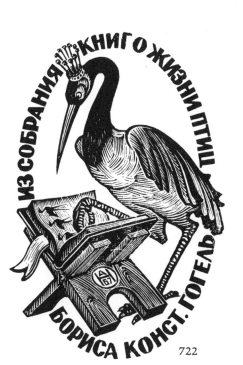

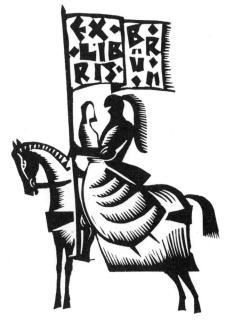

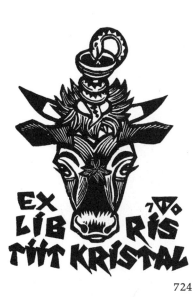

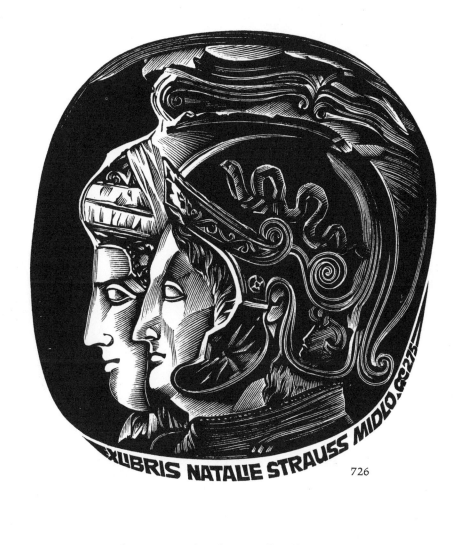

721: Henno Arrak. 722: A. T. Nagovitzin (for Boris K. Gogel). 723: G. I. Ratner.
724: Vaino Tonisson. 725: Silvi Valjal. 726: Anatolii Kalashnikov.

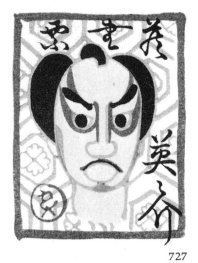

727

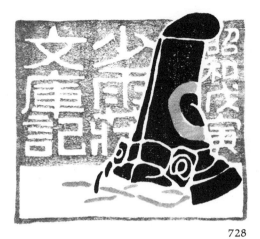

728

EX-LIBRIS·TADAO FUJII

729

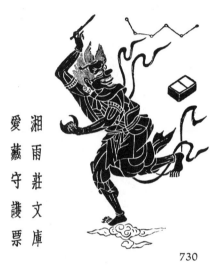

730

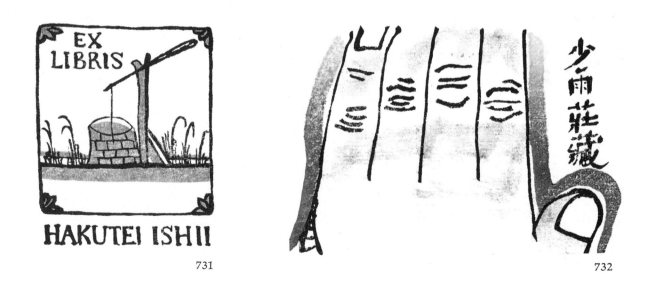

731

732

727: Keison Ushida. 728: Rin-ichiro Ohta. 729: Kiichi Ikedo. 730: Un-ichi Hiratsuka. 731: Hakutei Ishii. 732: Yukie Kumode.

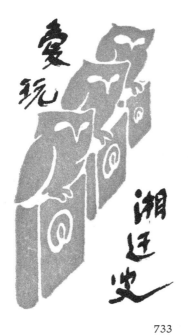

733

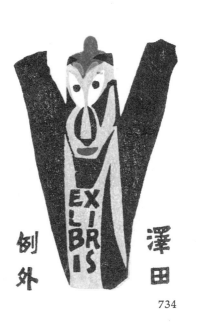

734

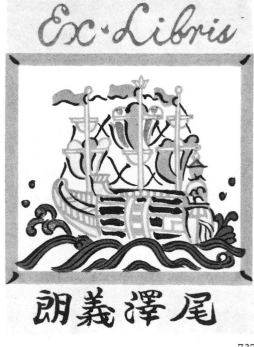

735

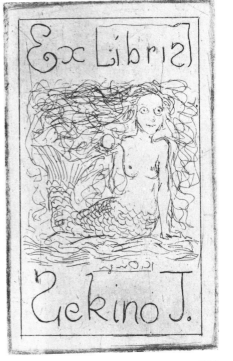

736

737

733: Rin-ichiro Ohta. 734: Buzan Iijima. 735: Yutaro Nakagawa. 736: Kohshiro
Onchi. 737: Sumio Kawakami.

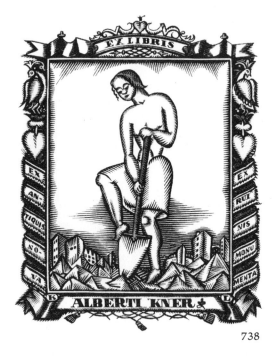

738

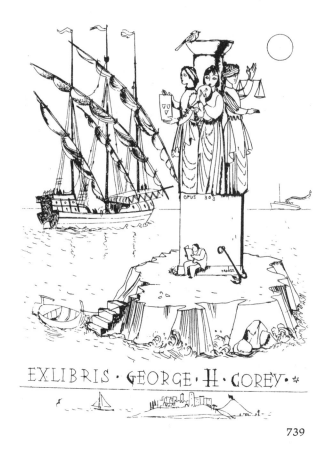

739

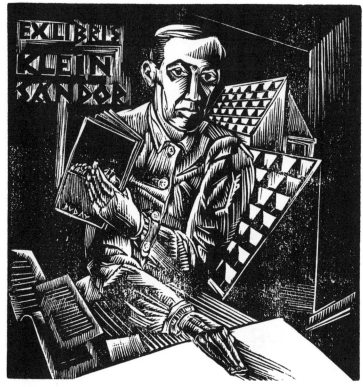

740

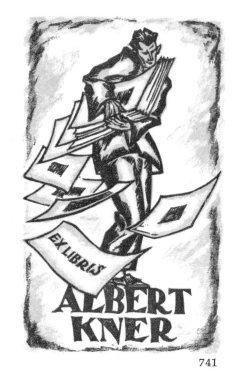

741

738: Ludovic Kozma. 739: Endre Vadasz. 740: Gyorgy Buday. 741: Anonymous.

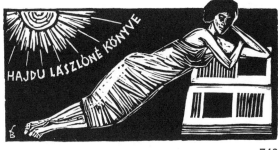

742

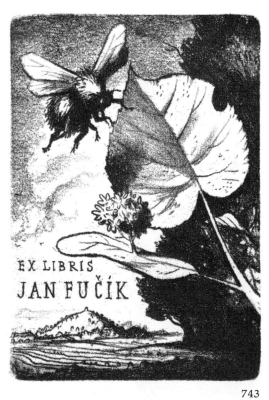

743

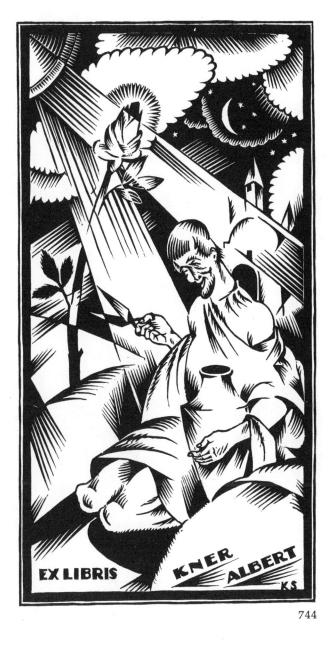

744

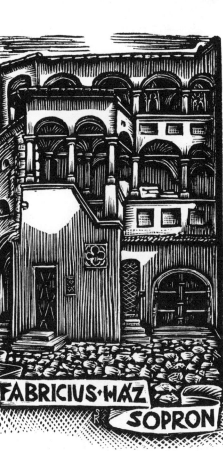

745

742: Béla Stettner. 743: Jan Fucik. 744: Sandor Kolozsvary. 745: Karoly Sterbenz.

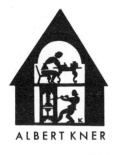

ALBERT KNER

746

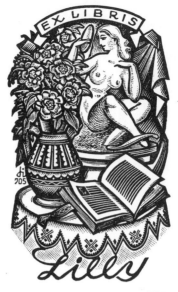

747

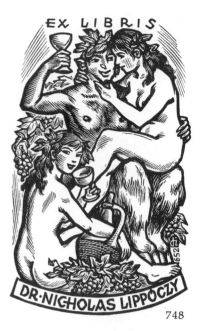

748

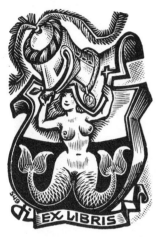

749

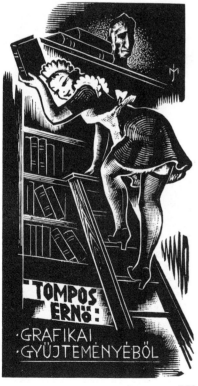

750

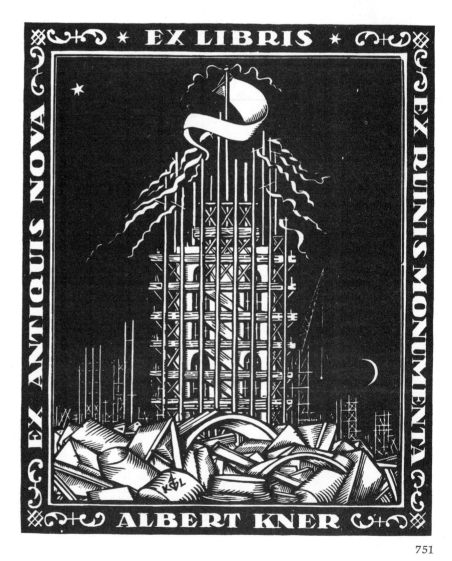

751

746: Albert Kner. 747-749: Istvan Drahos (749, owner unknown). 750: Josef Menyhart. 751: Ludovic Kozma.

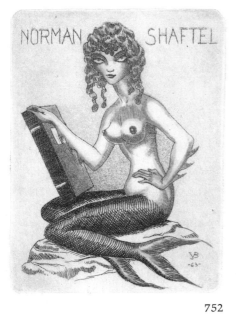

752

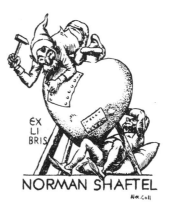

753

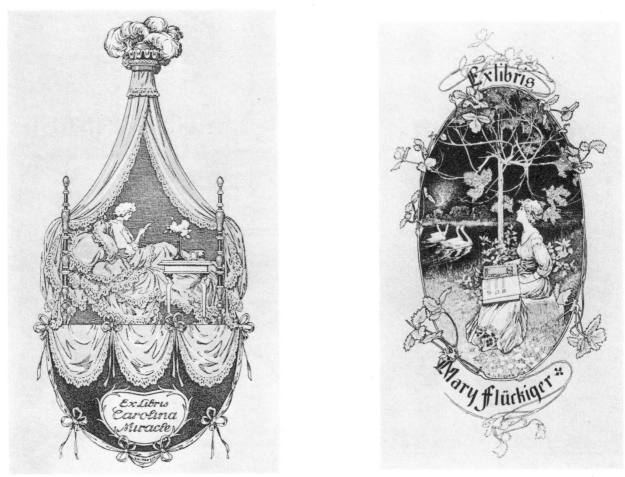

754

755

752: Juan Vicente Botello. 753: Alex Coll. 754: José Triadó. 755: A. de Riquer.

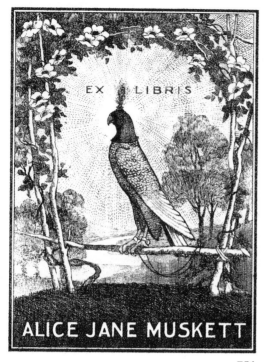

ALICE JANE MUSKETT

756

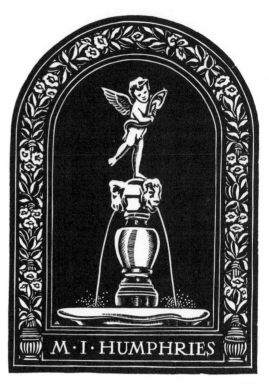

M·I·HUMPHRIES

757

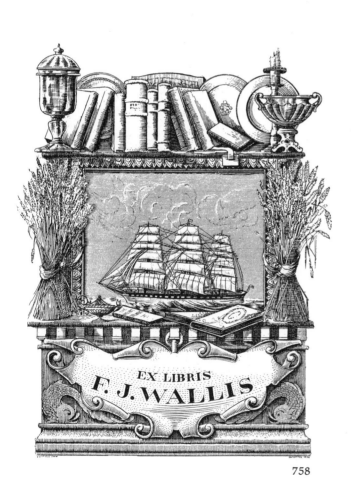

EX LIBRIS
F. J. WALLIS

758

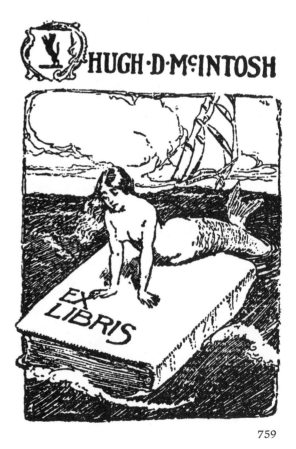

HUGH·D·McINTOSH

EX LIBRIS

759

756 & 757: Adrian Feint. 758: Gayfield Shaw. 759: Norman Lindsay.

INDEX OF ARTISTS

References are to figure numbers rather than page numbers.

147